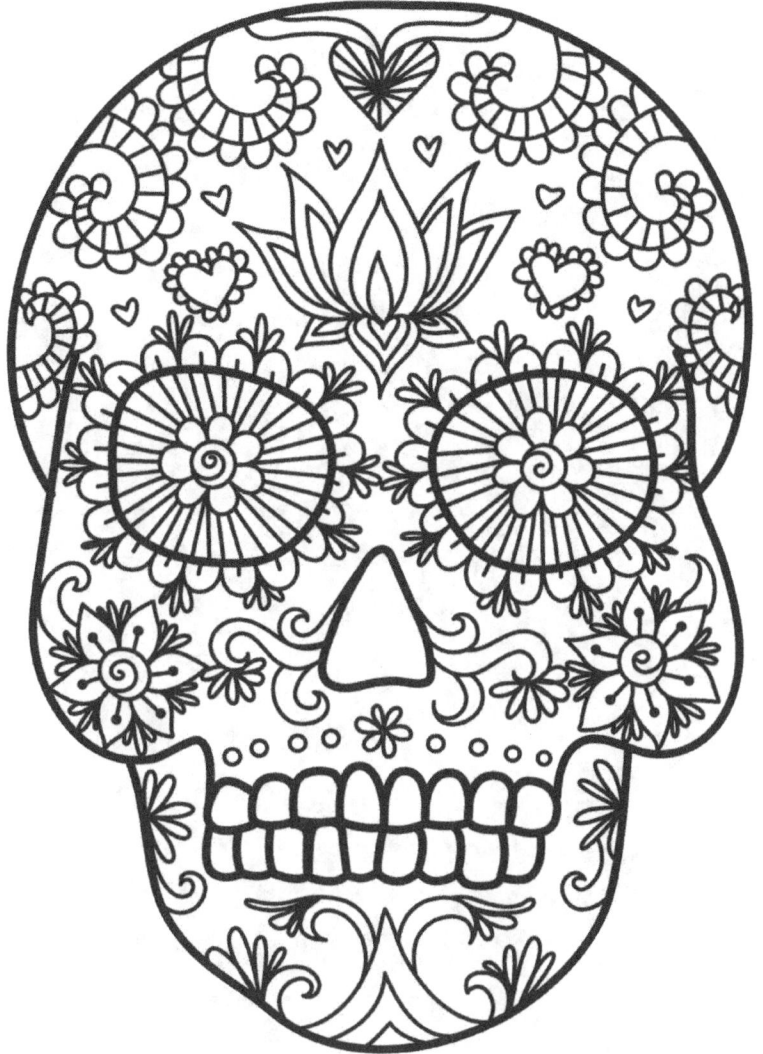

SUGAR SKULLS
Coloring Book For Adults

Copyright © 2019 Vunzi, LLC

All rights reserved. This book or any portion thereof

may not be reproduced or used in any manner whatsoever without the express written permission

of the publisher except for the use of brief quotations in a book review

ISBN-13: 978-1-0884-6344-4

Sample Pages

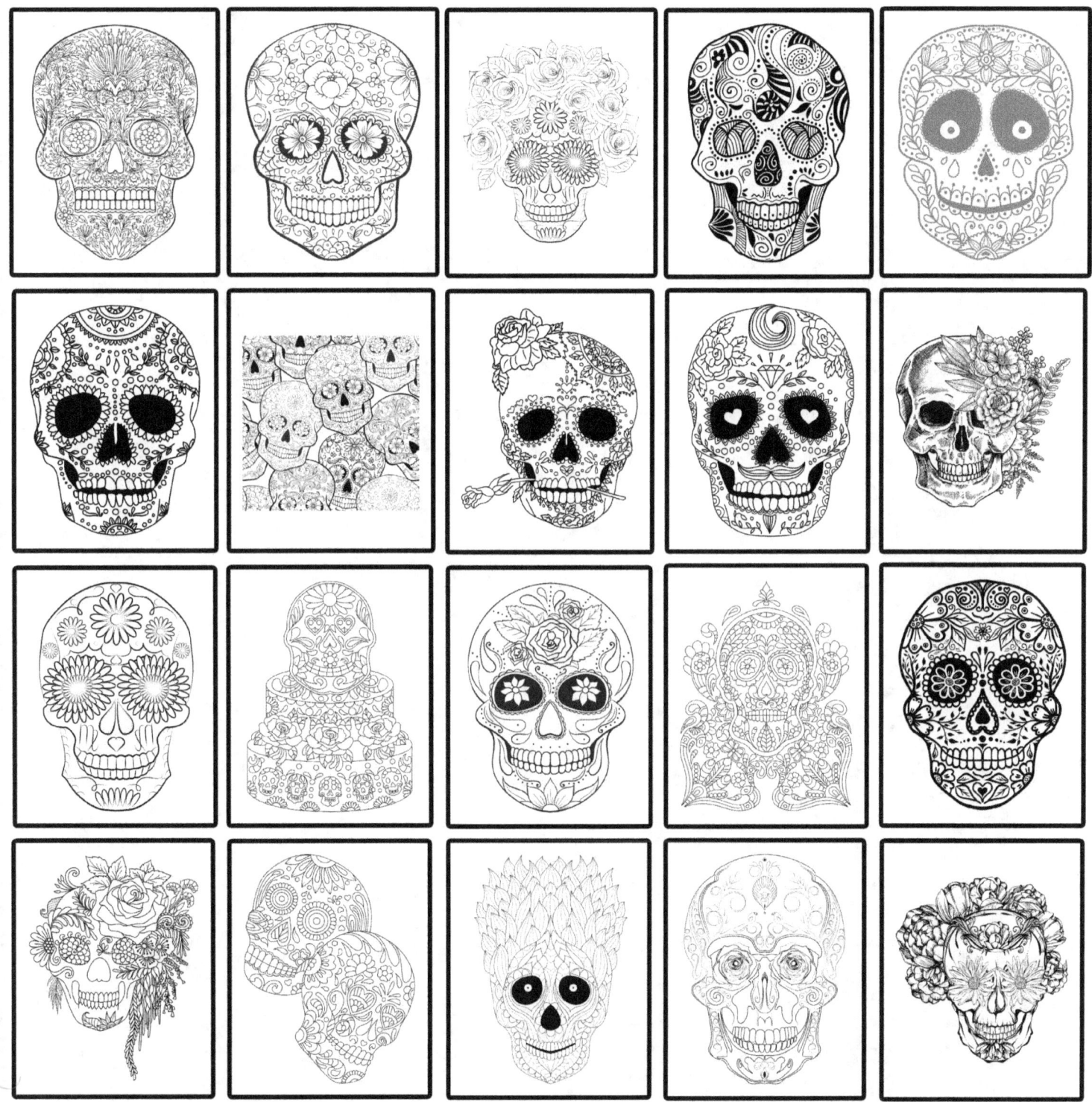

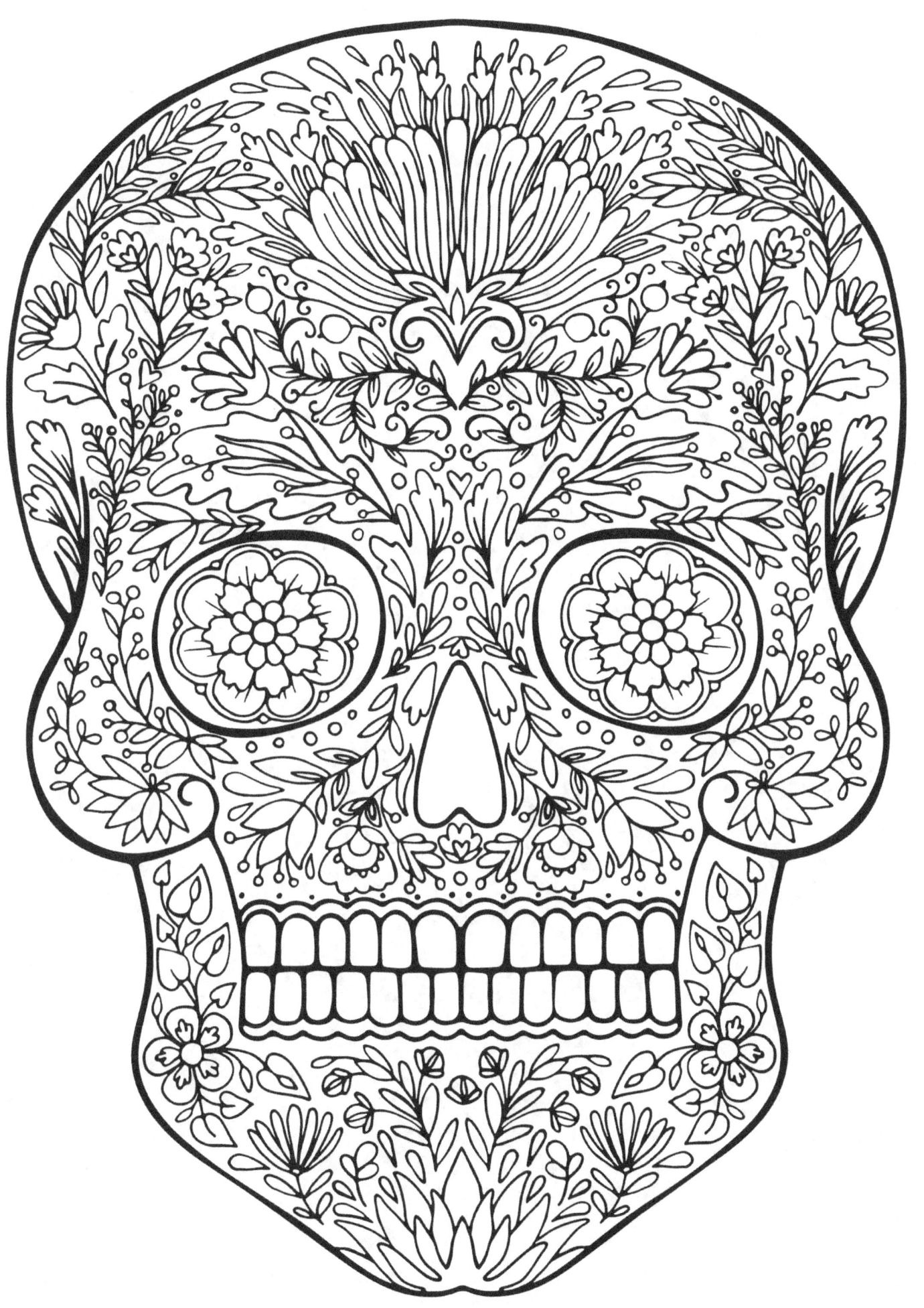

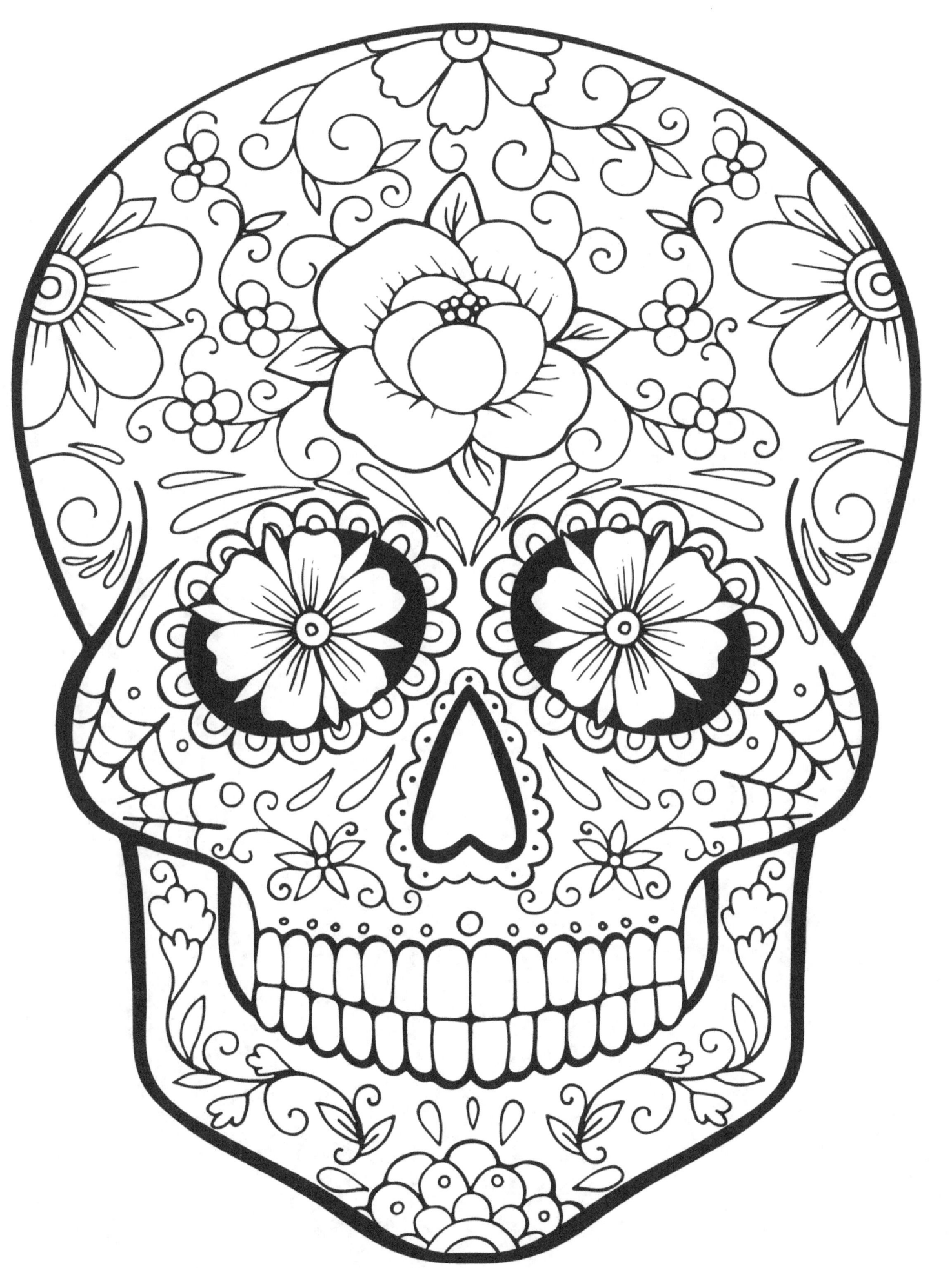

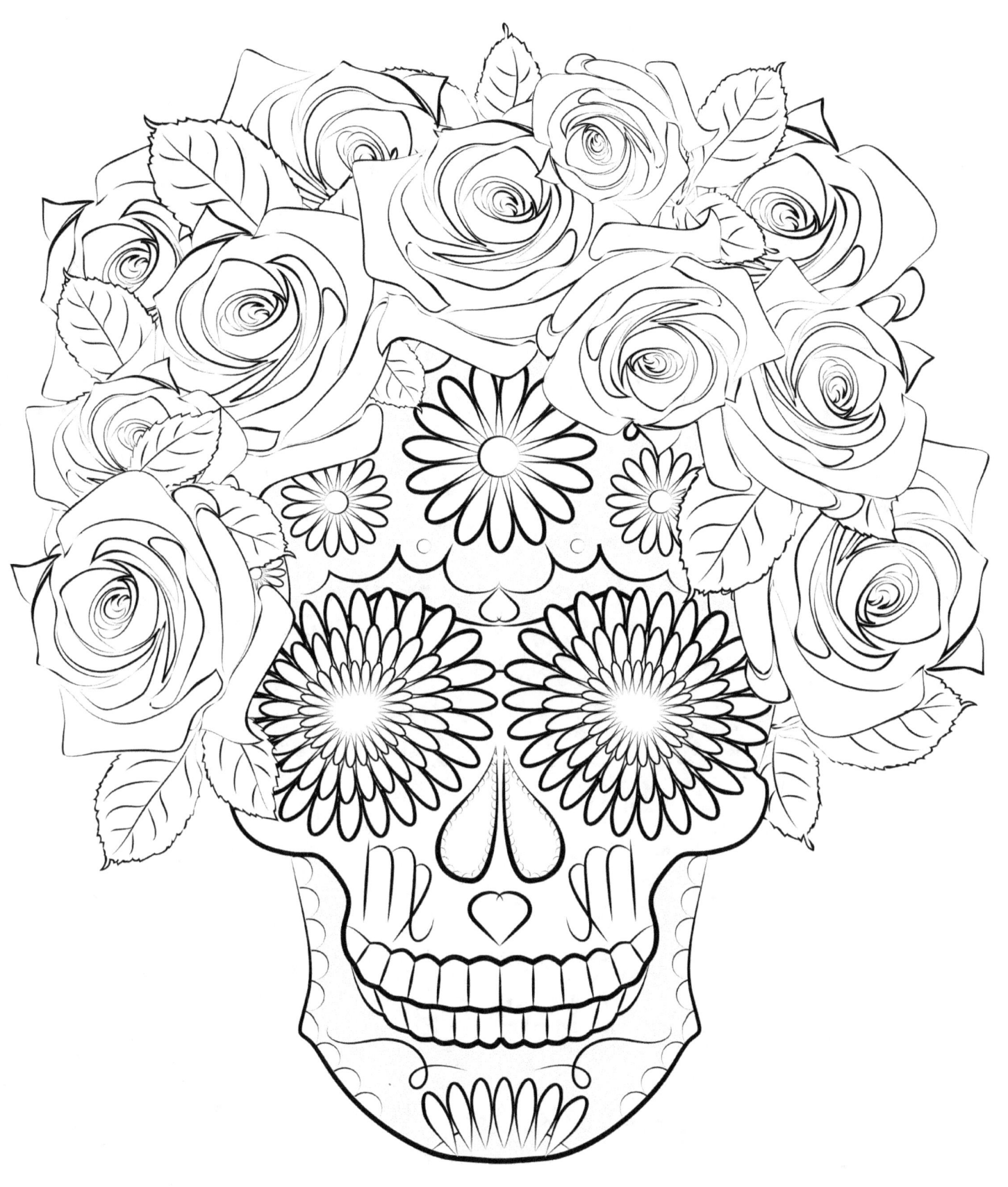

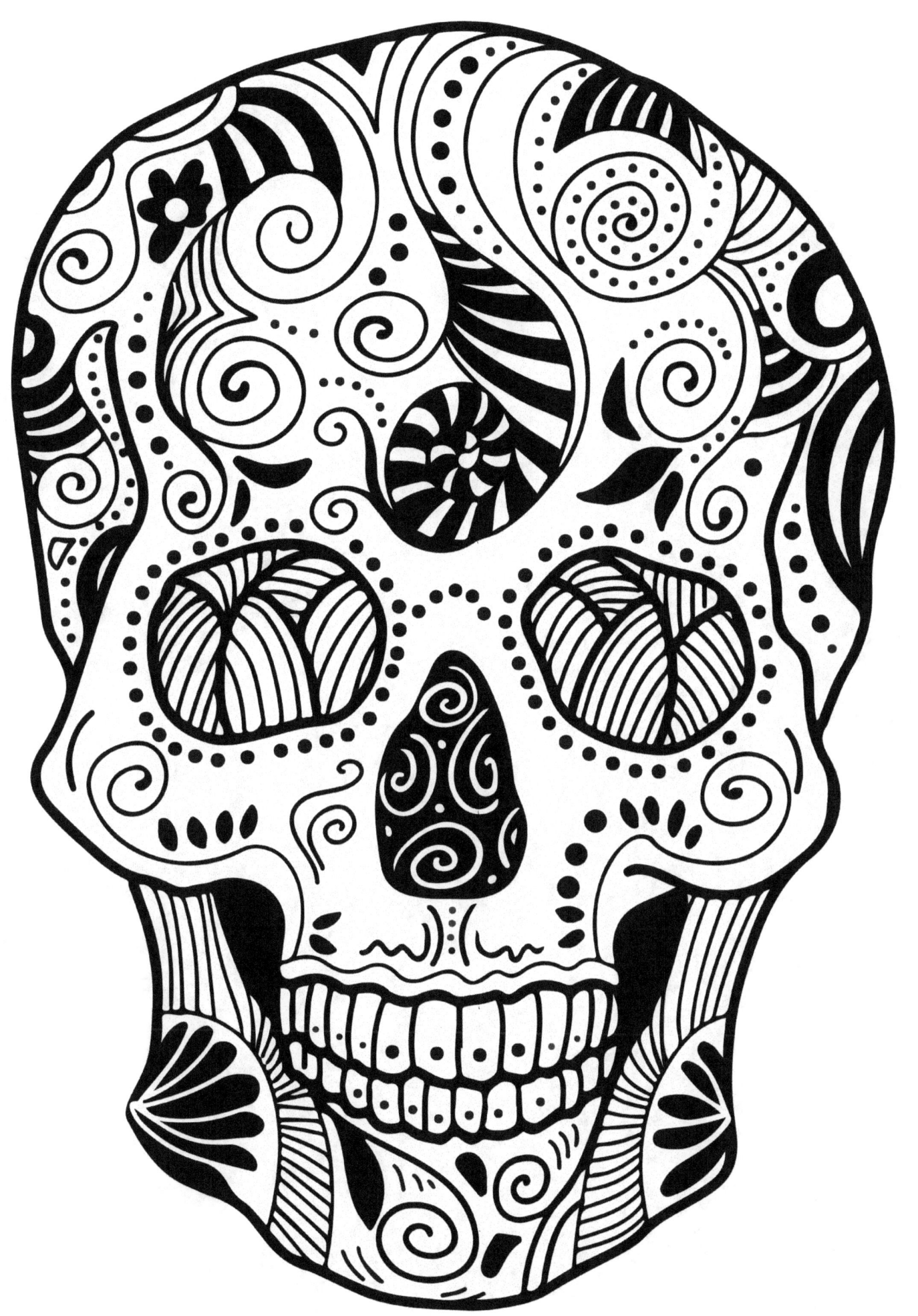

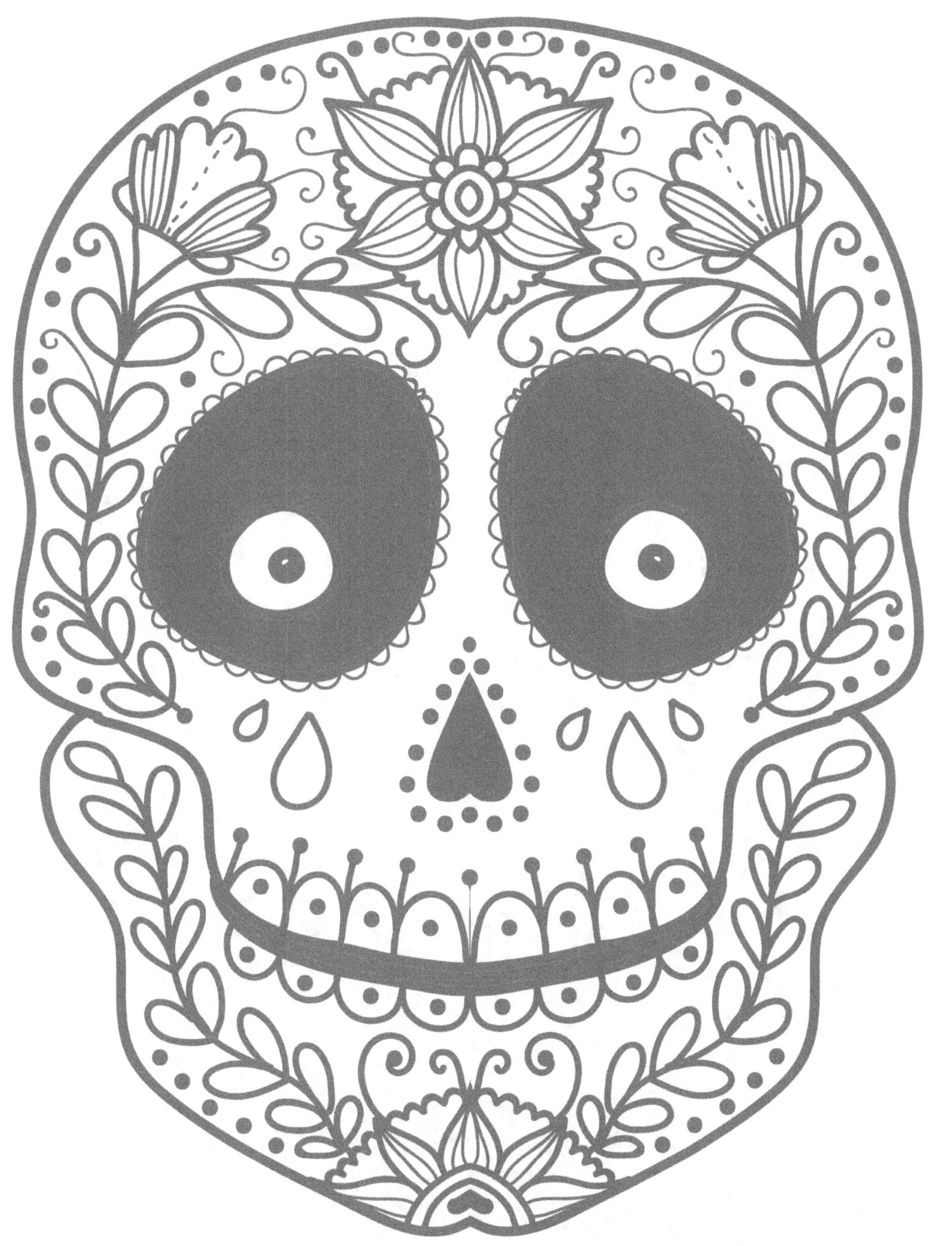

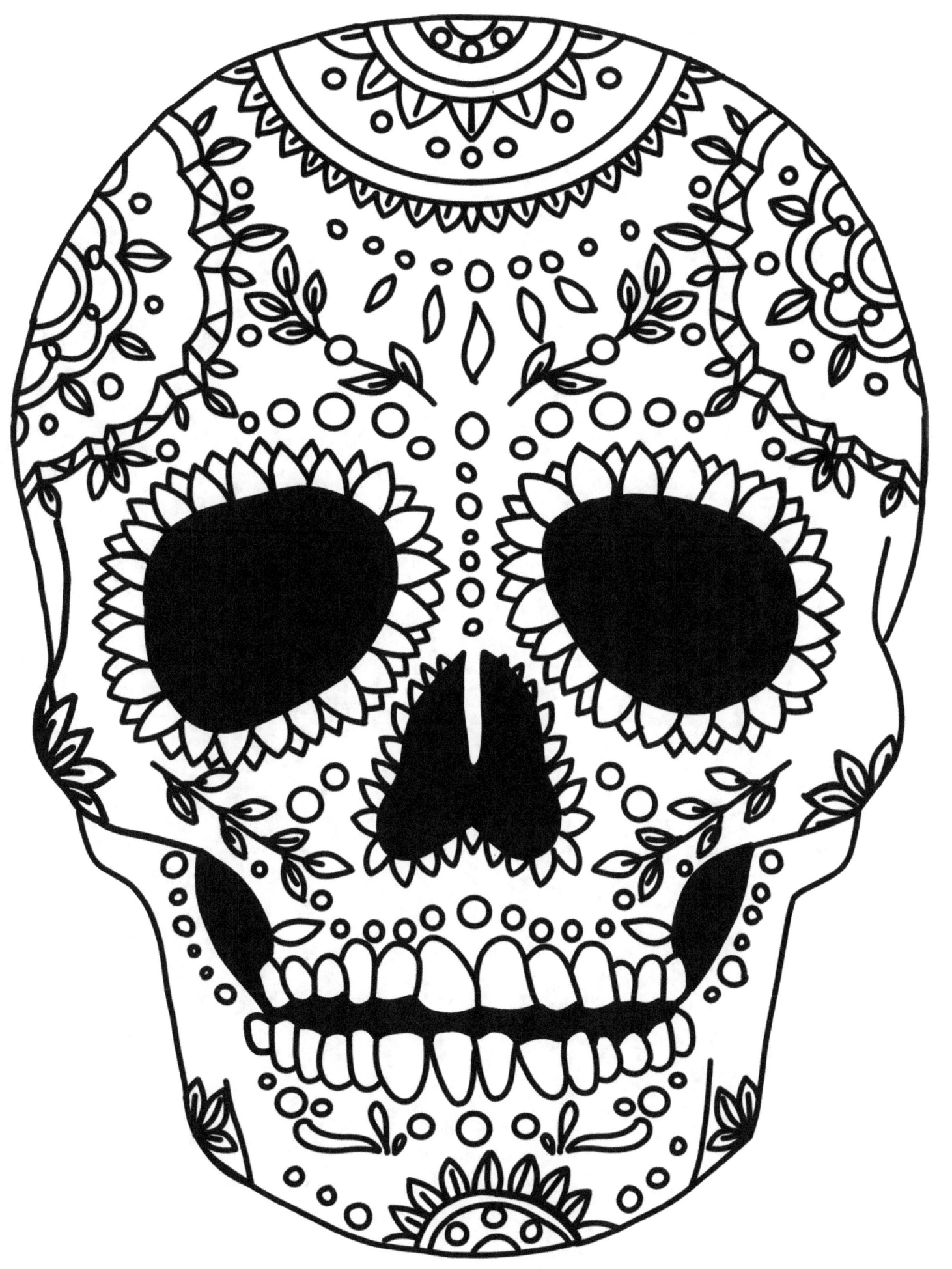

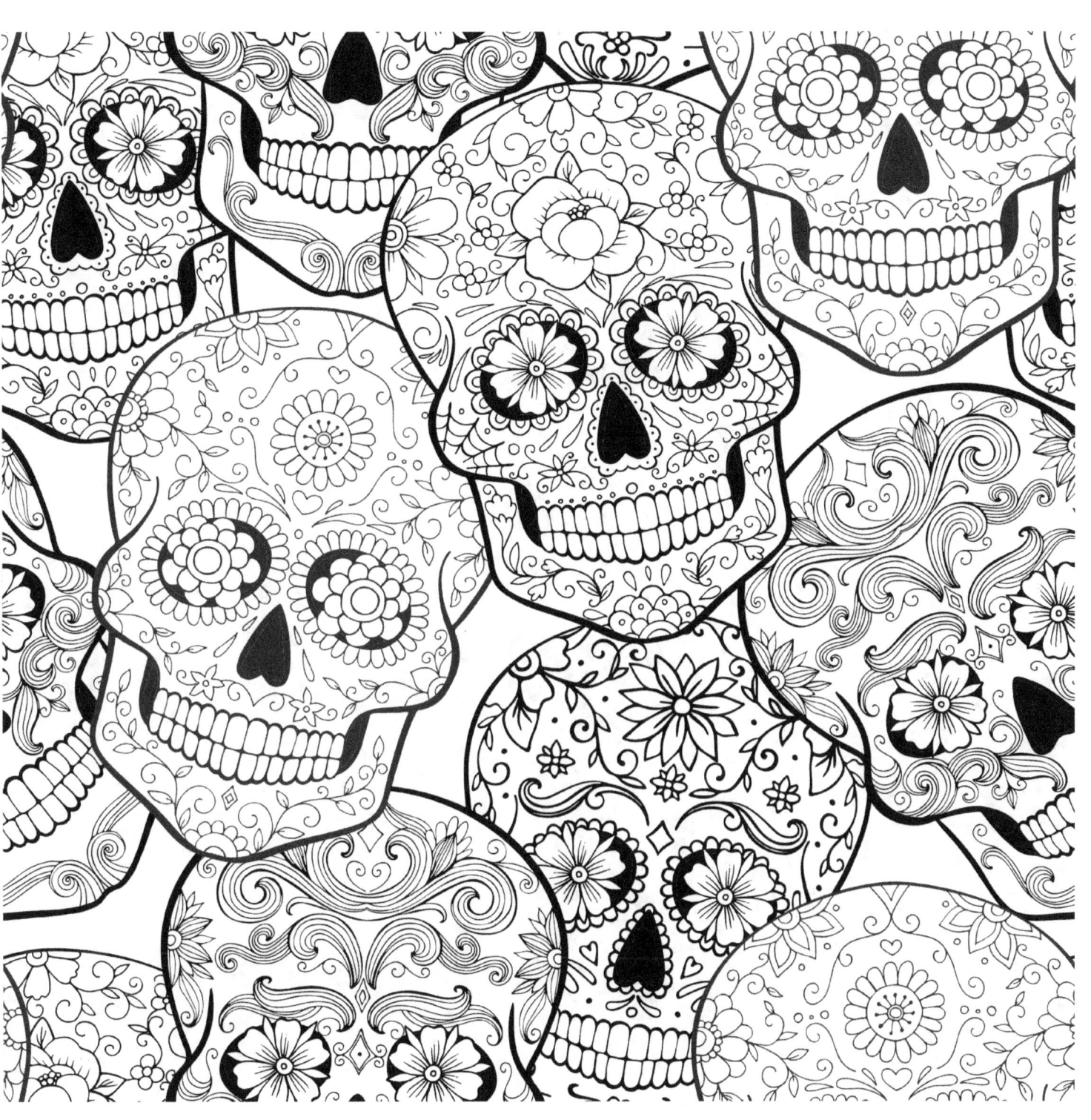

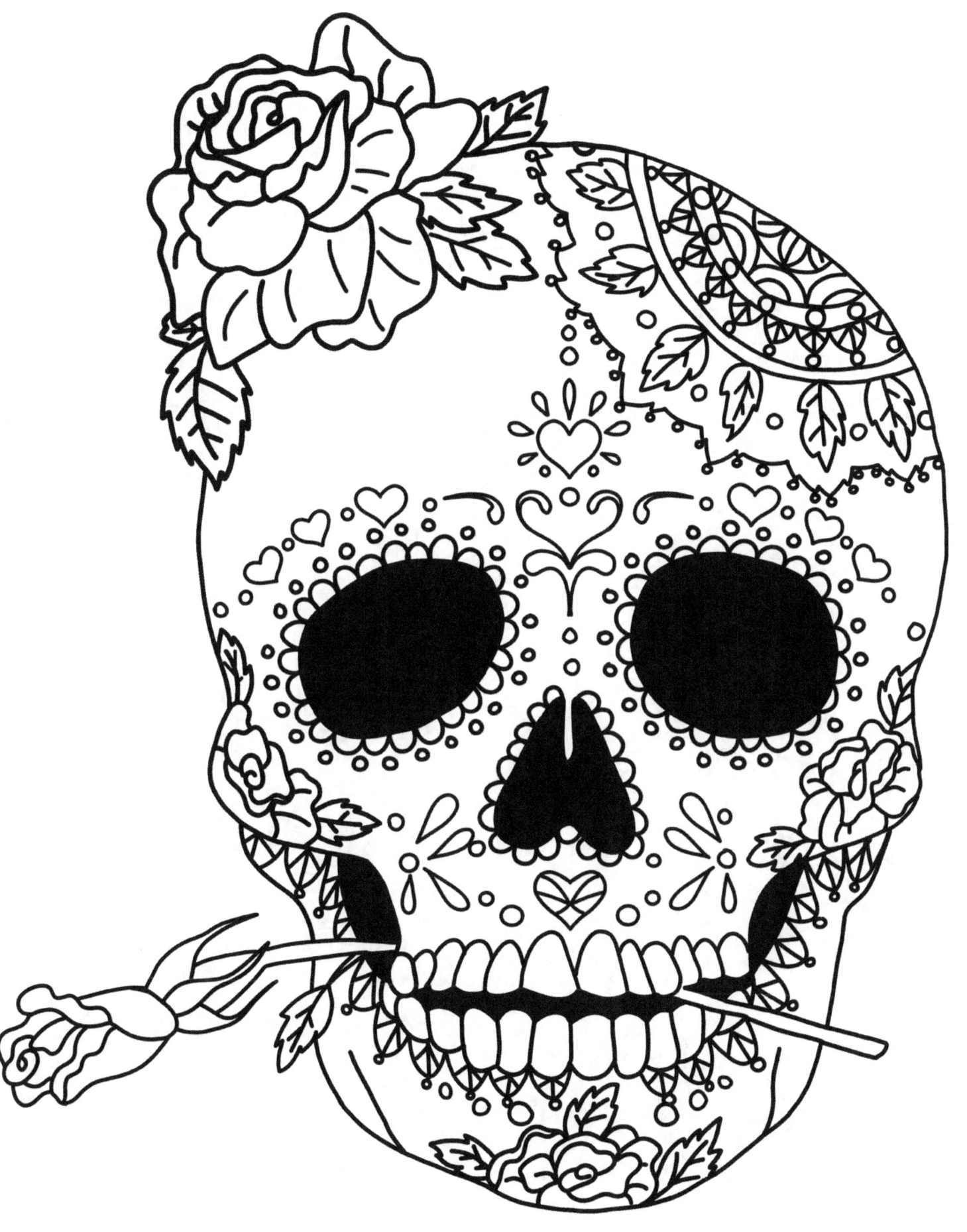

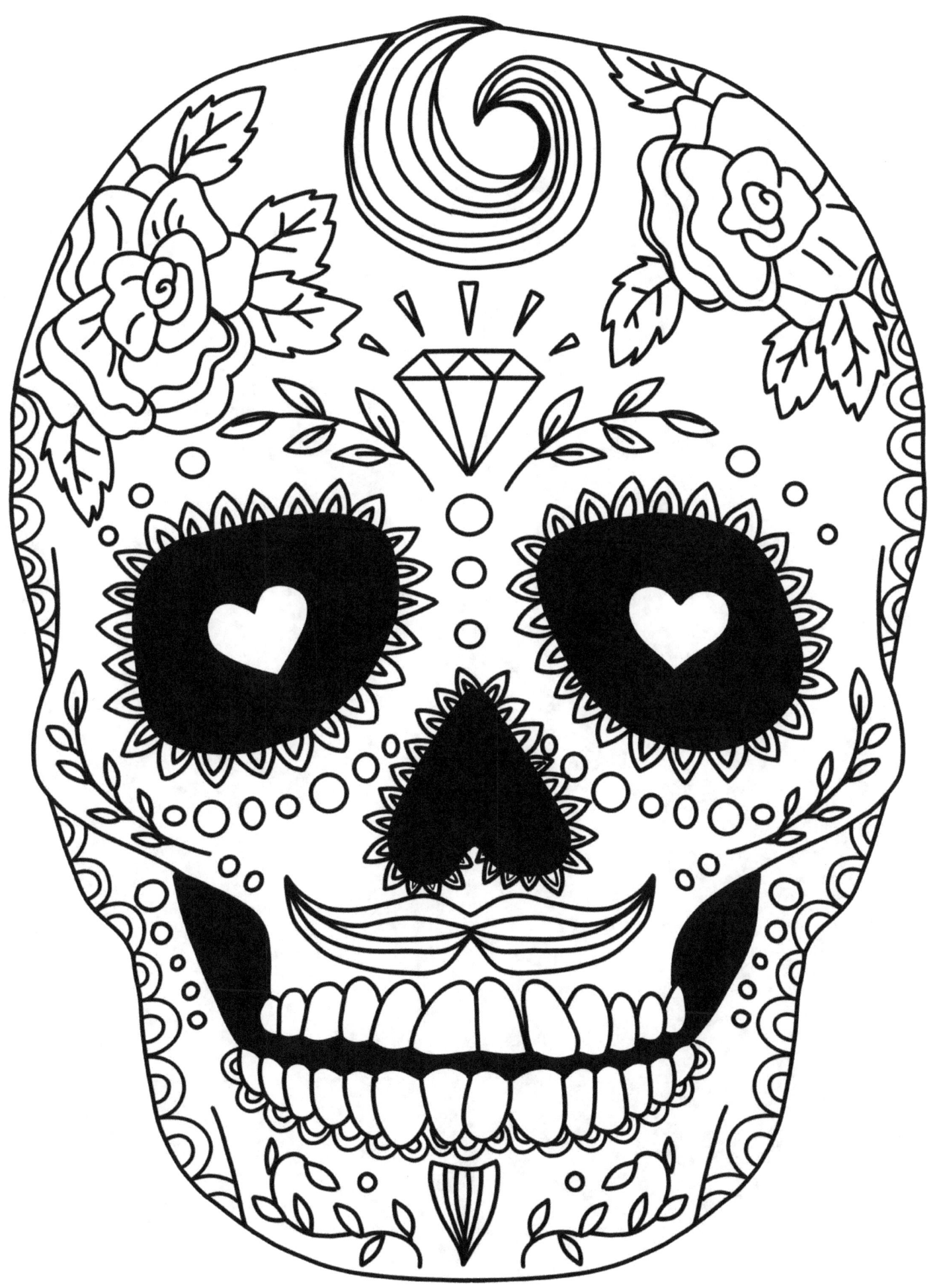

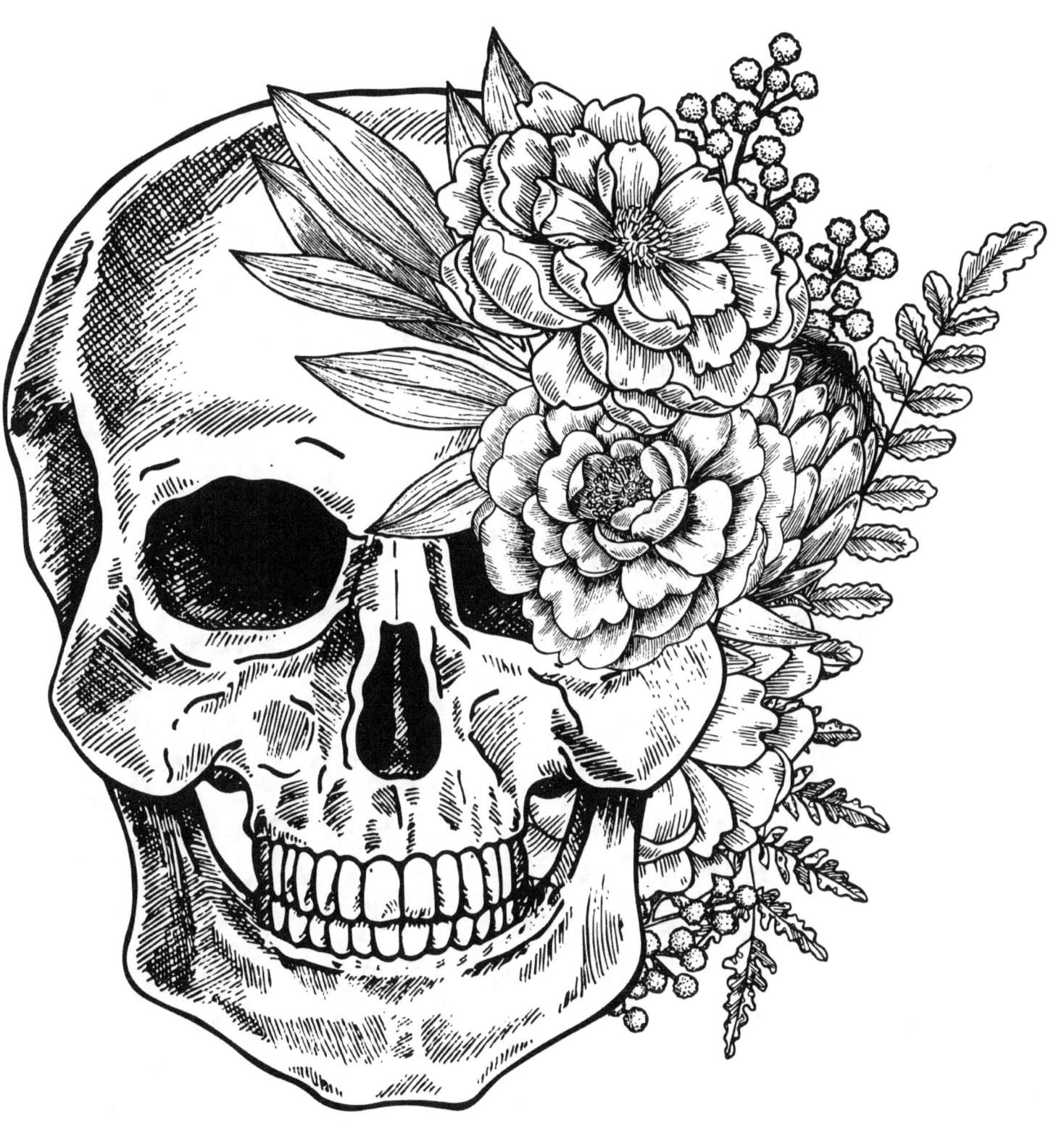

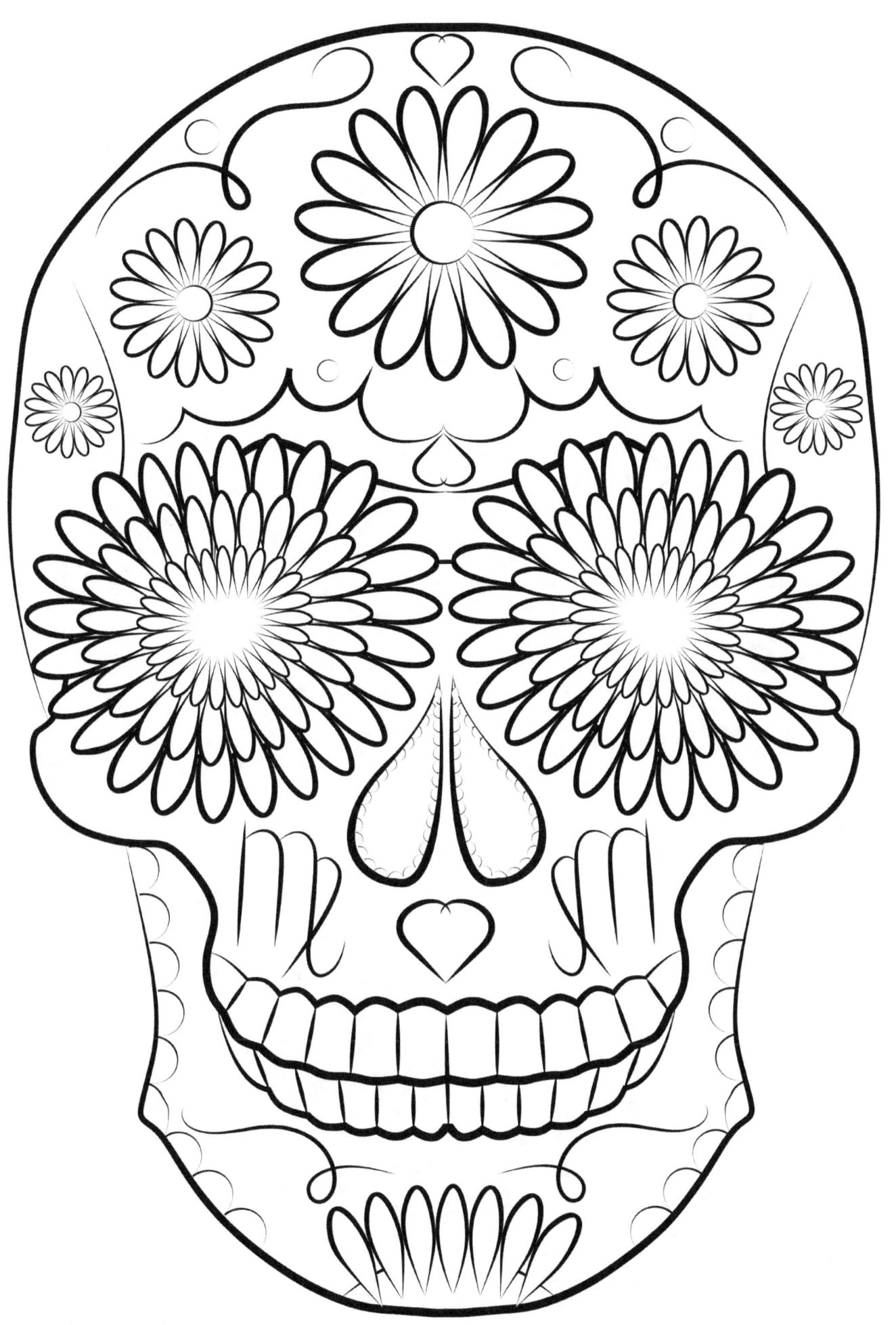

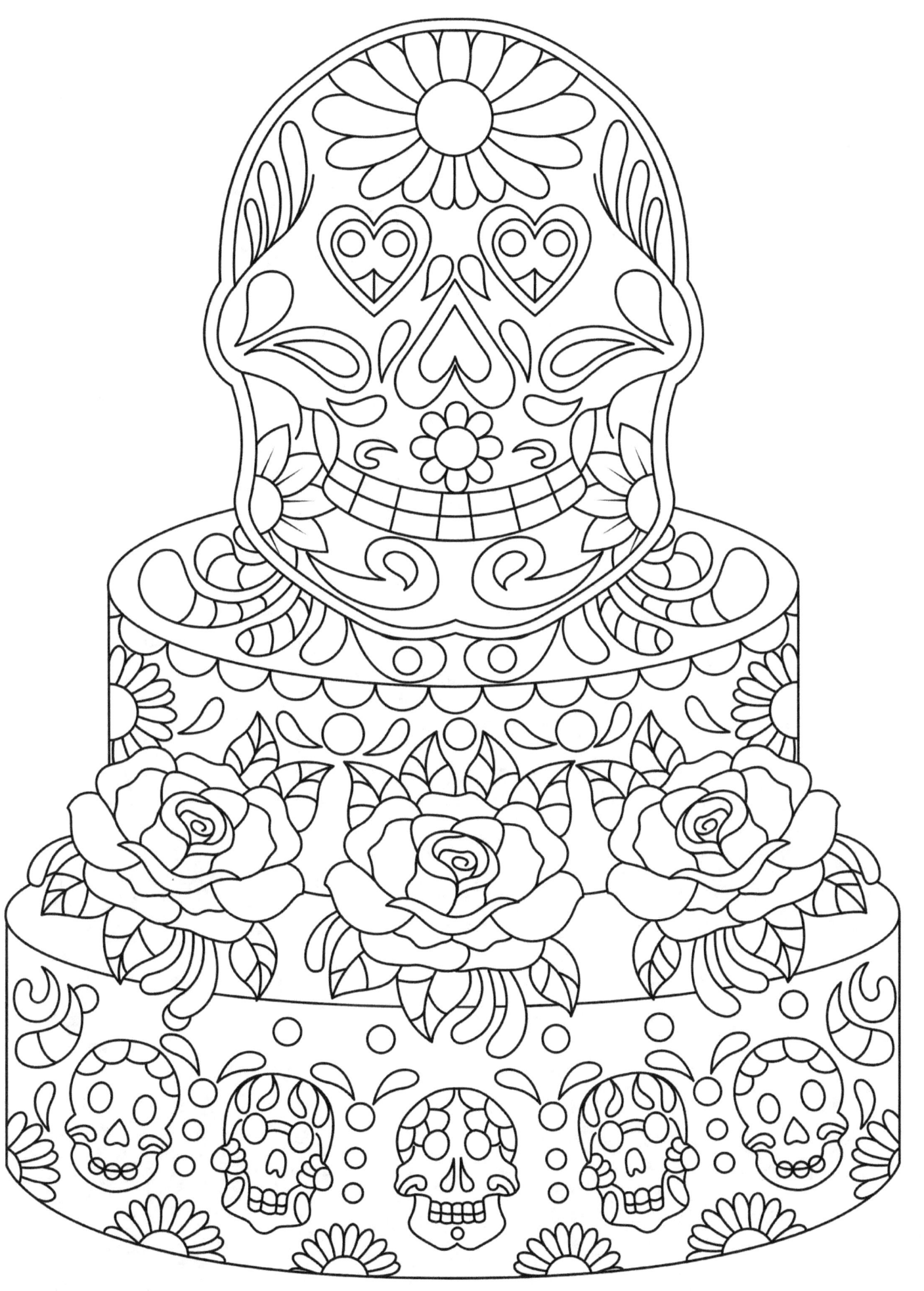

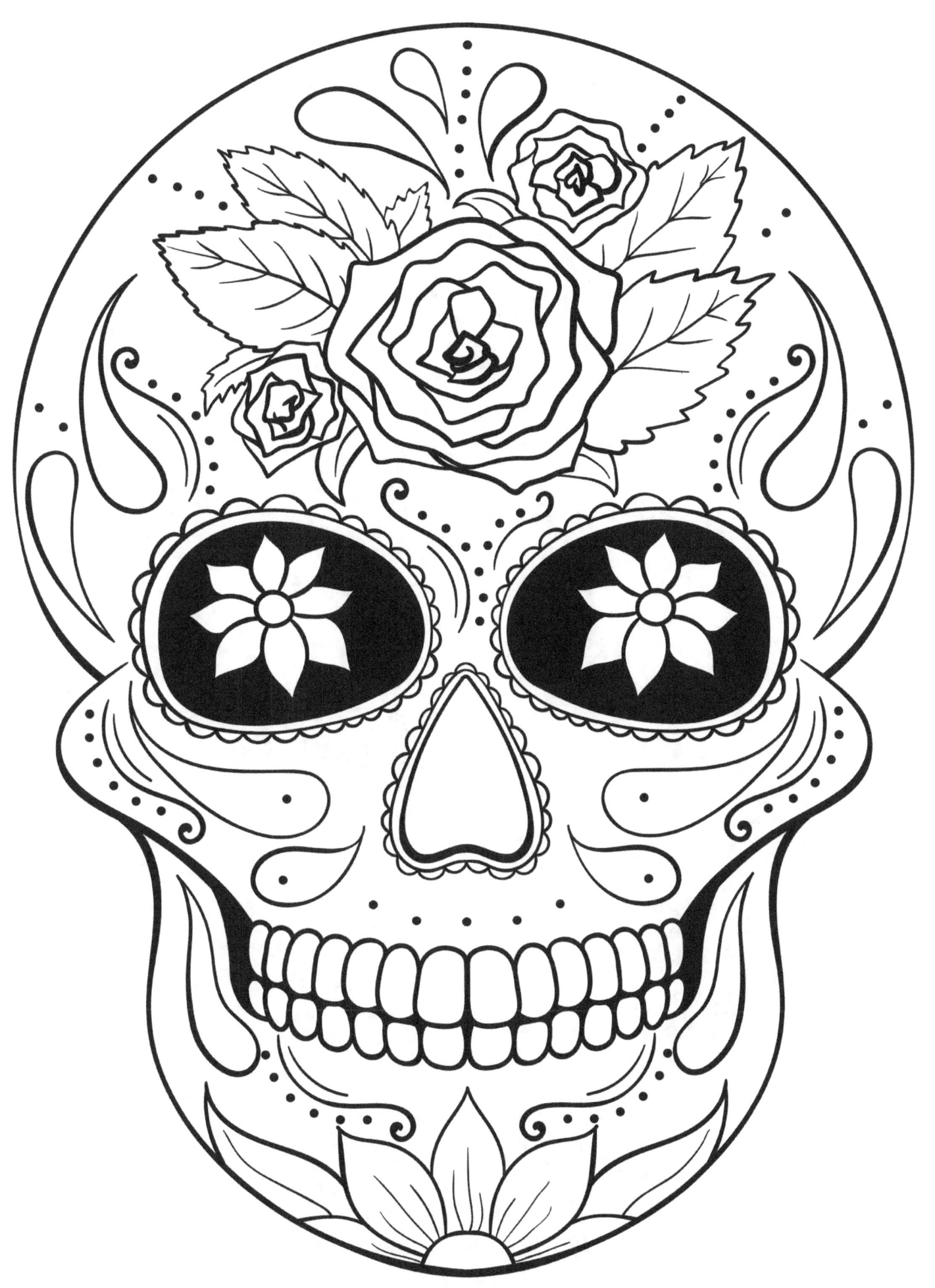

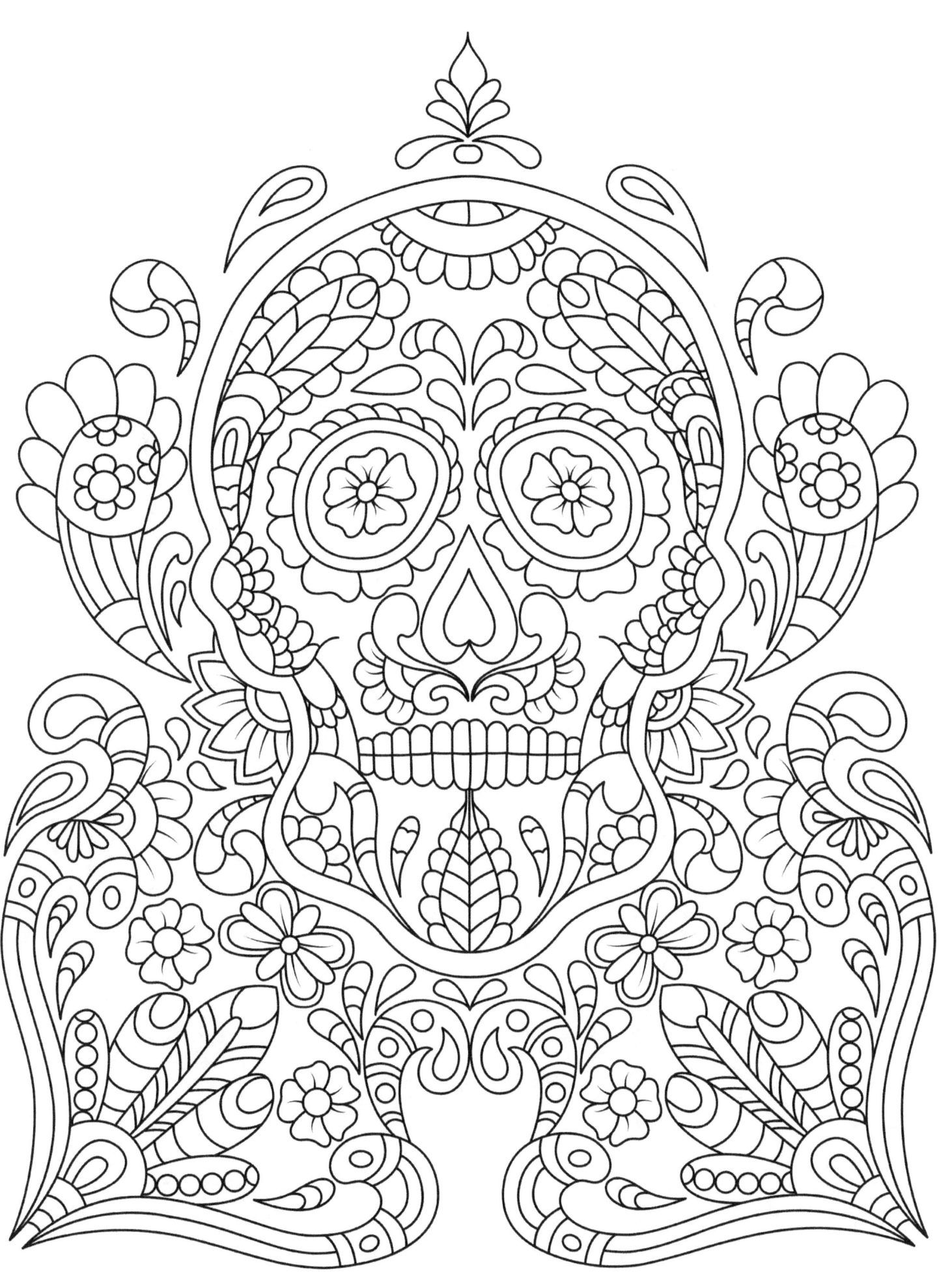

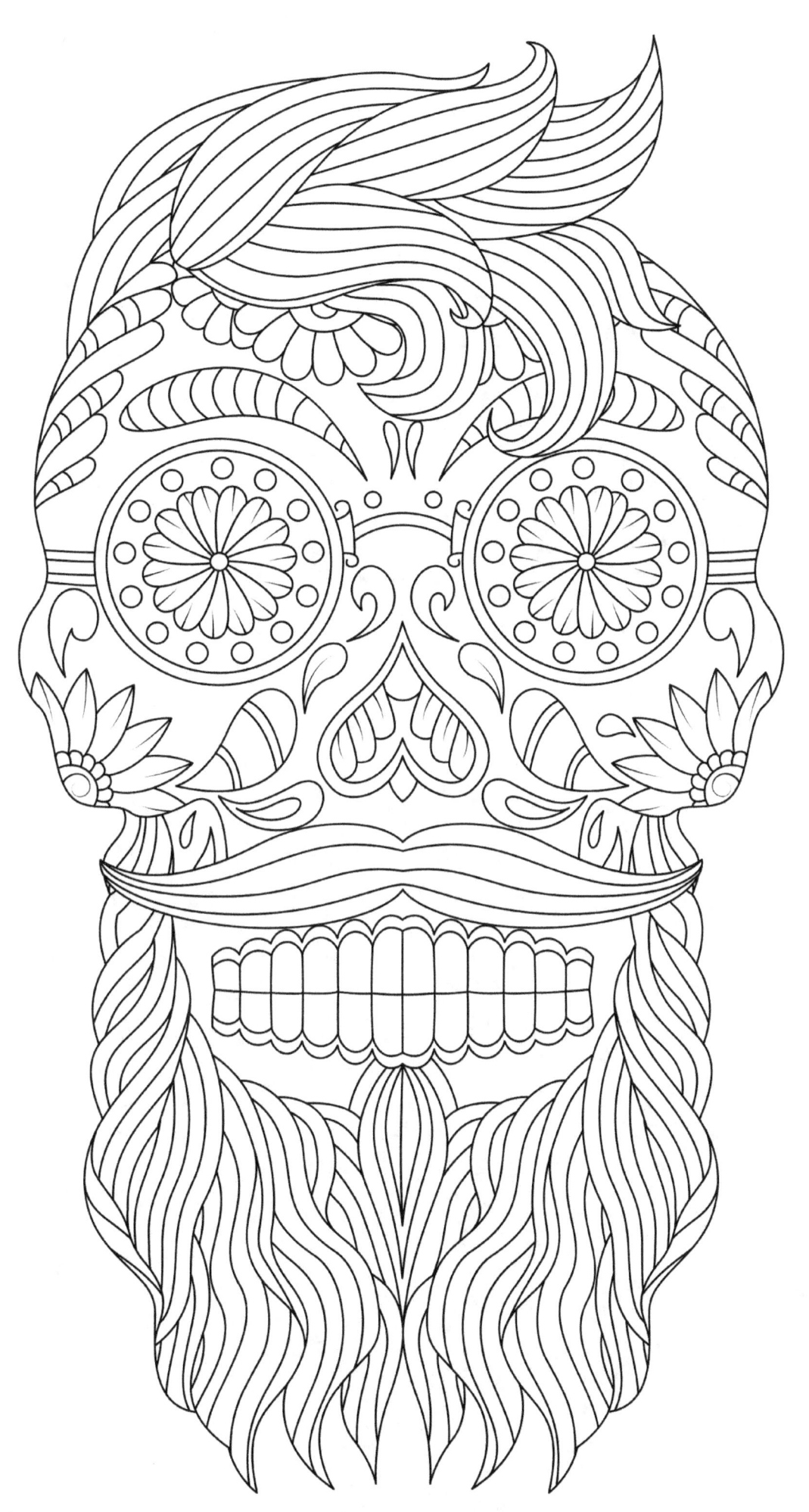

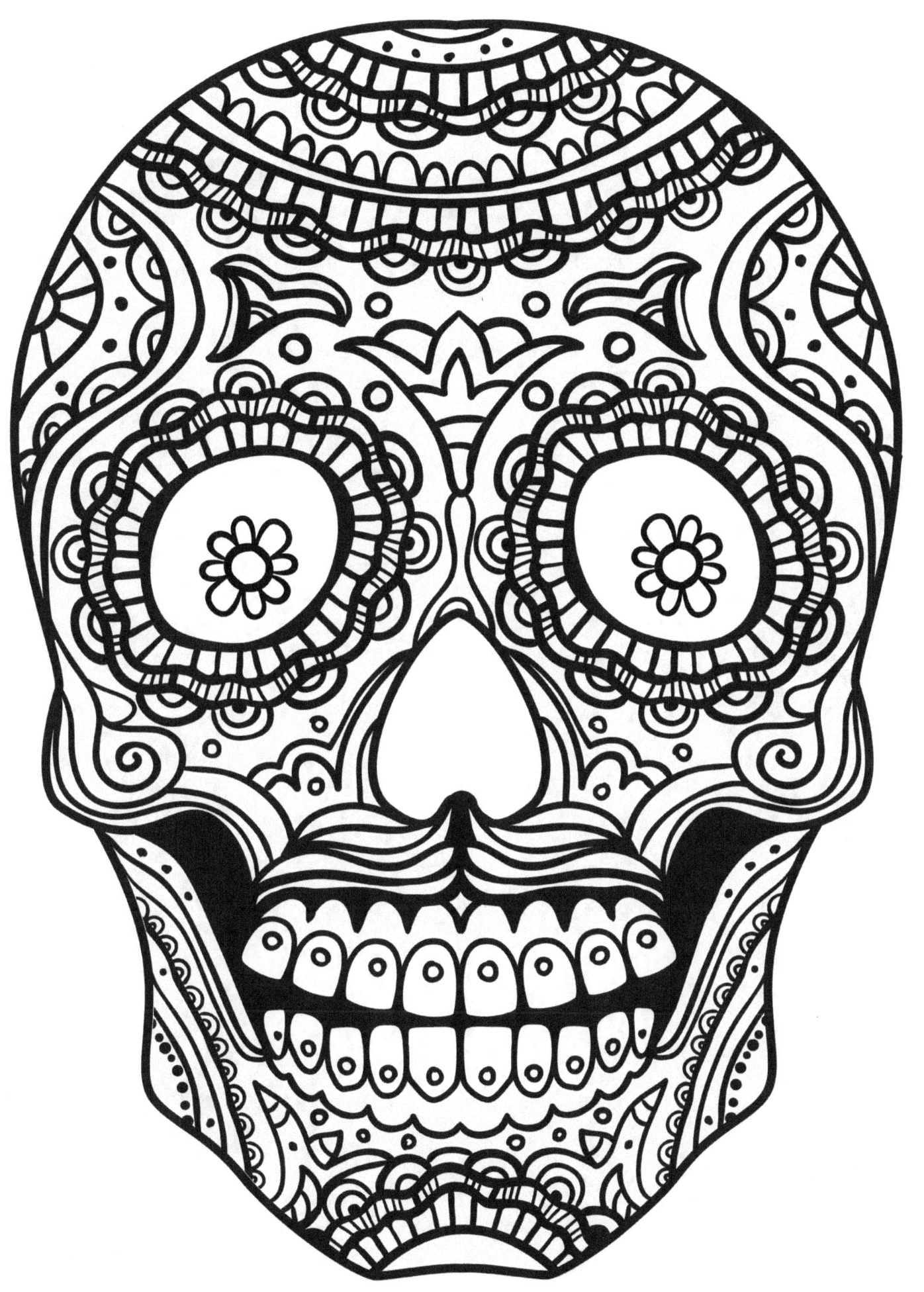

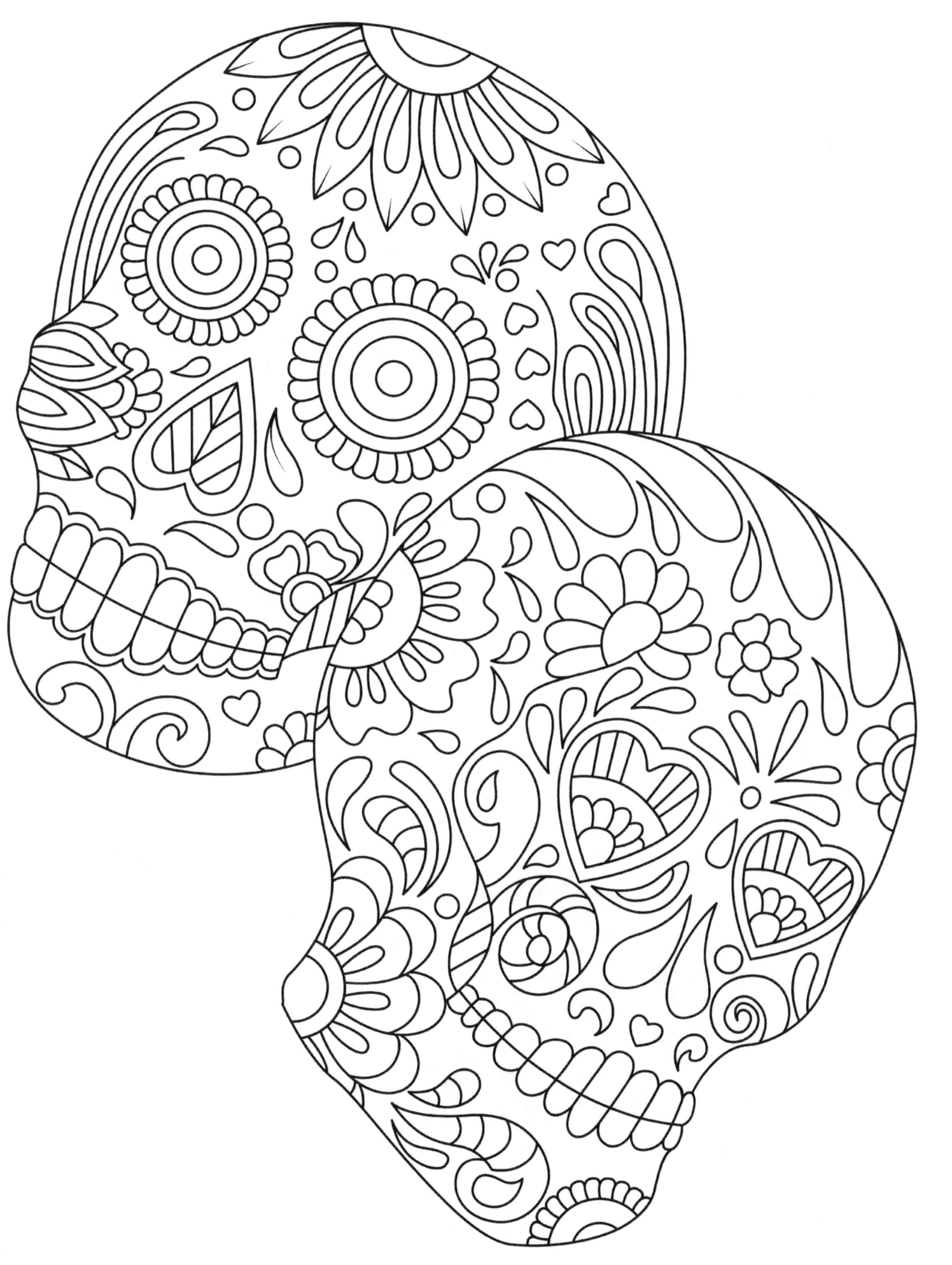

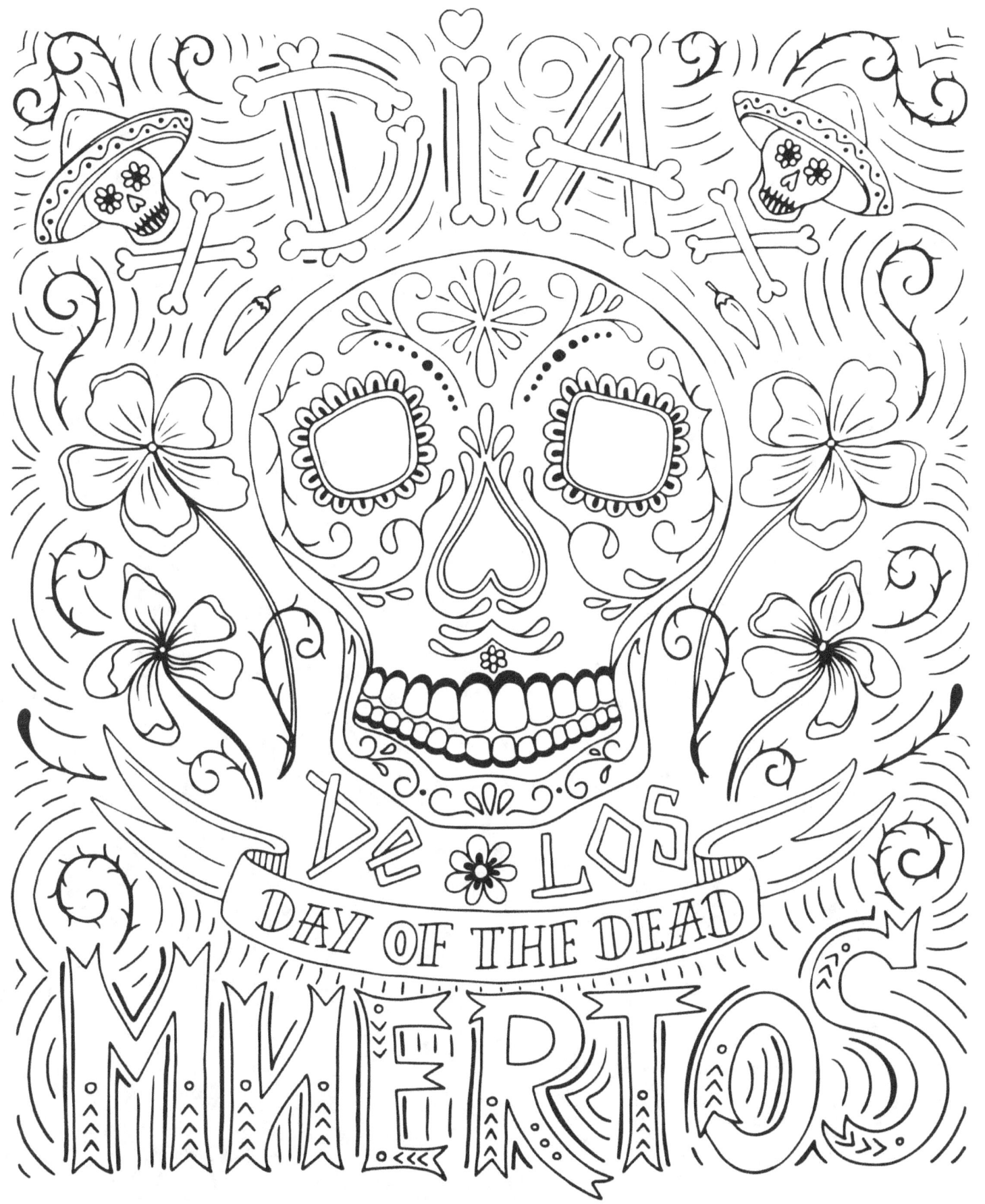

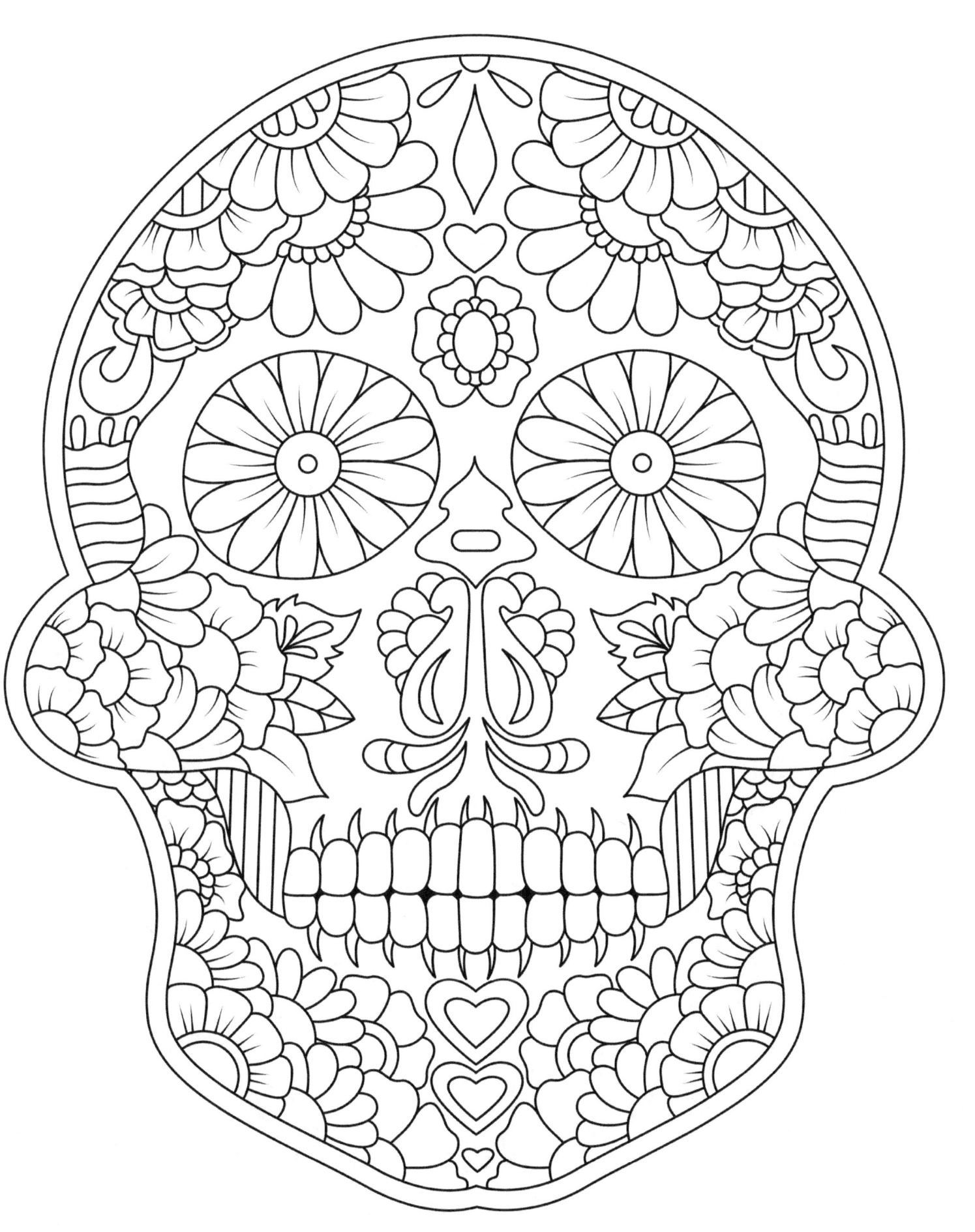

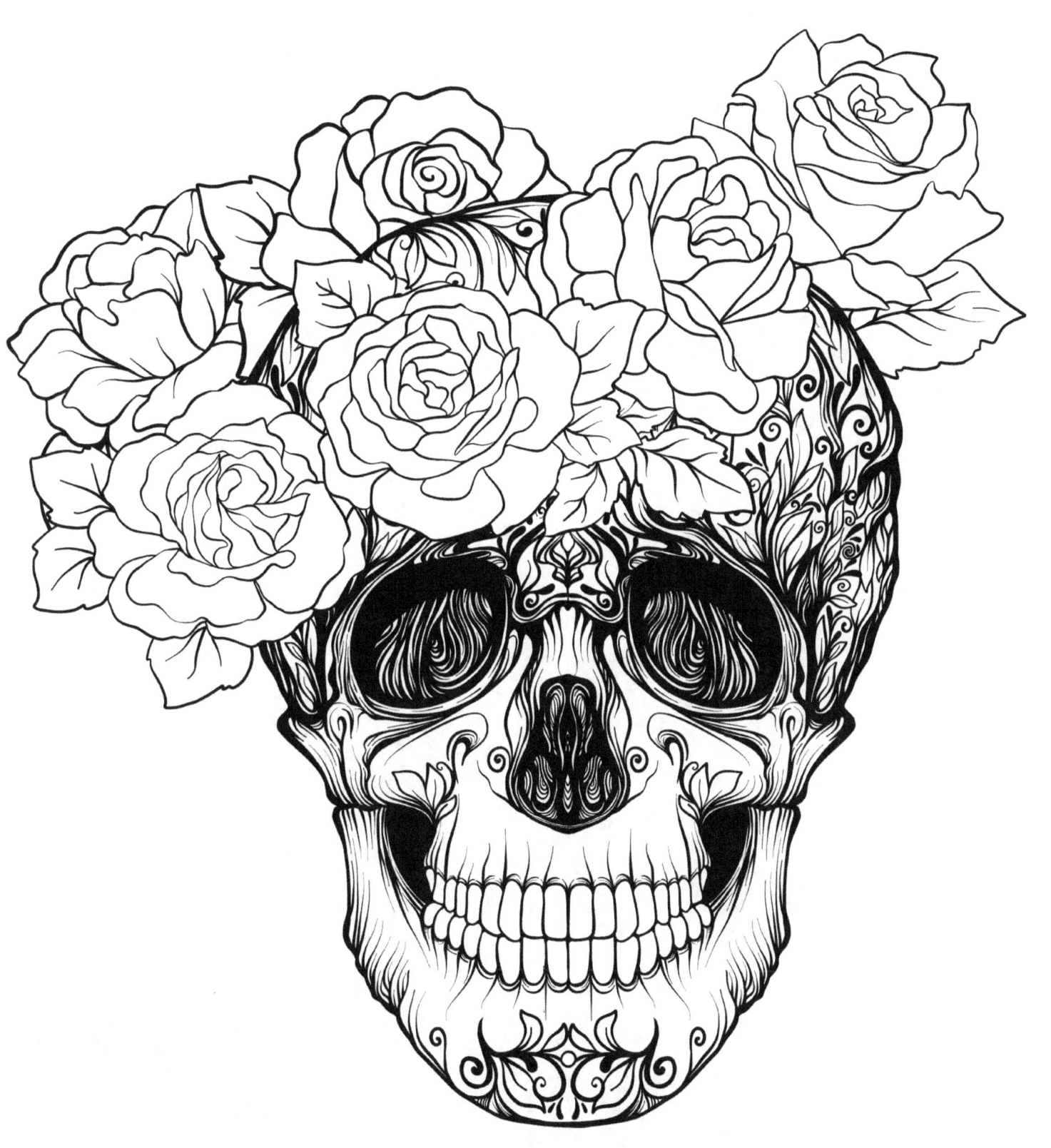

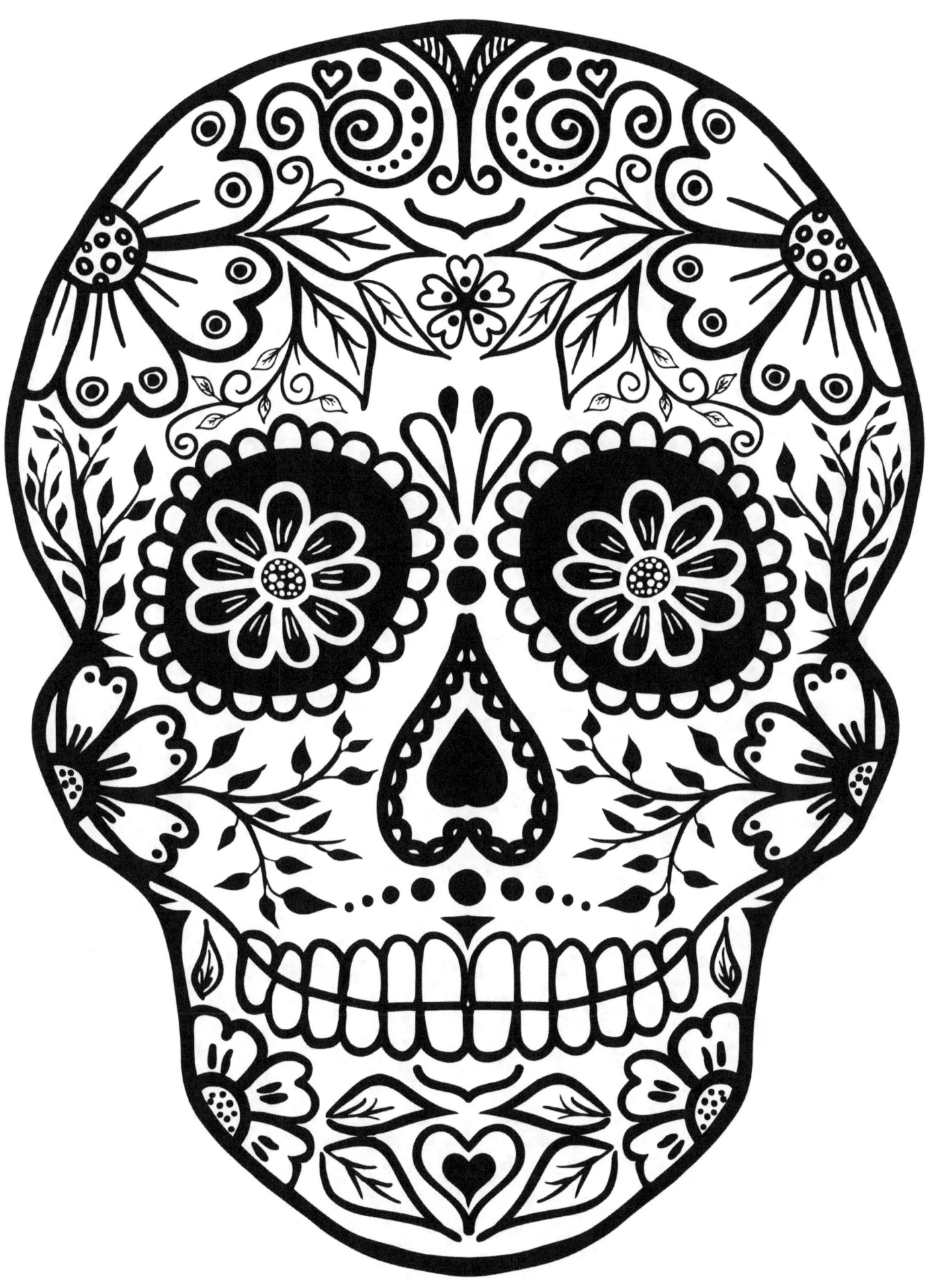

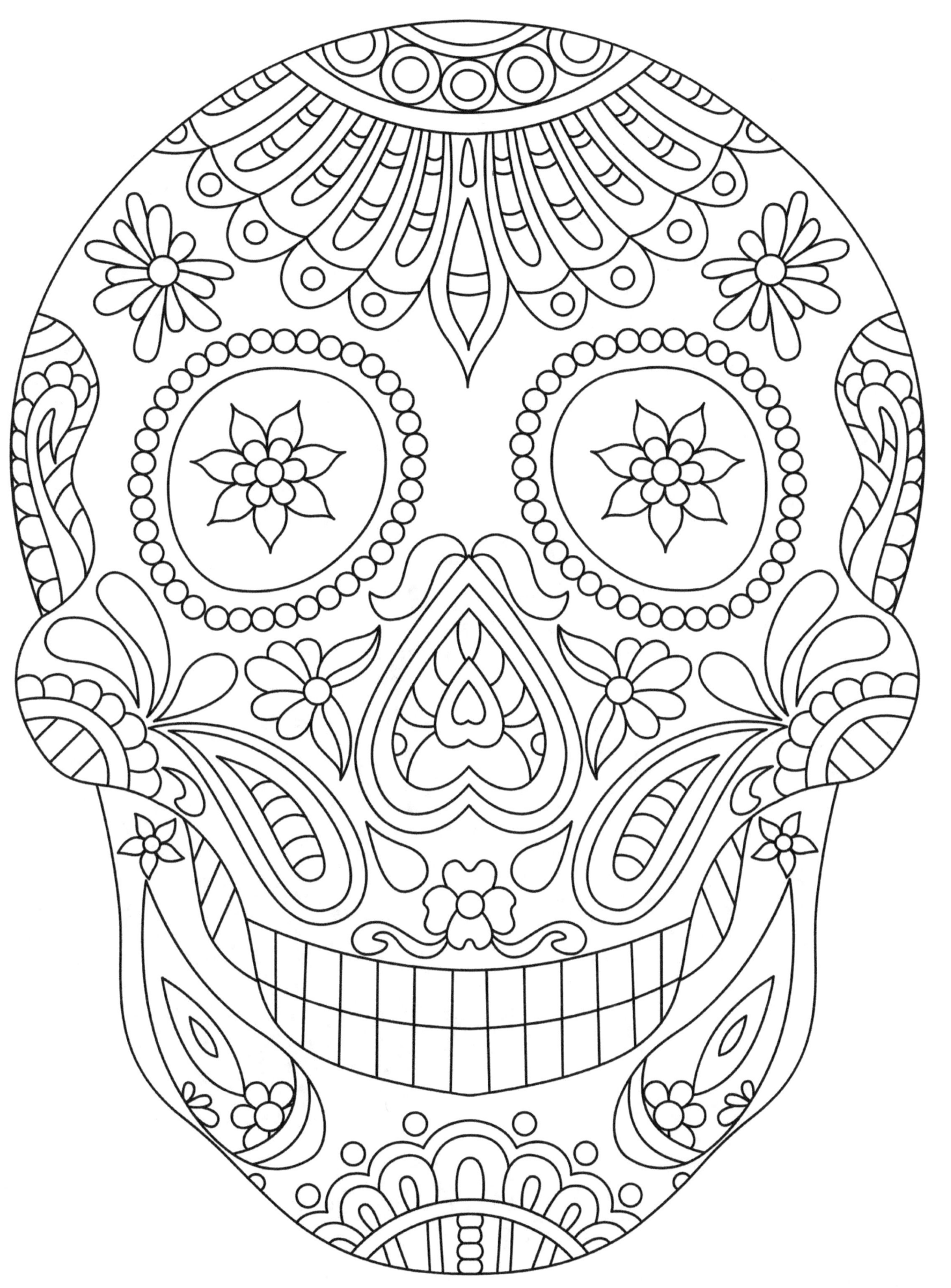

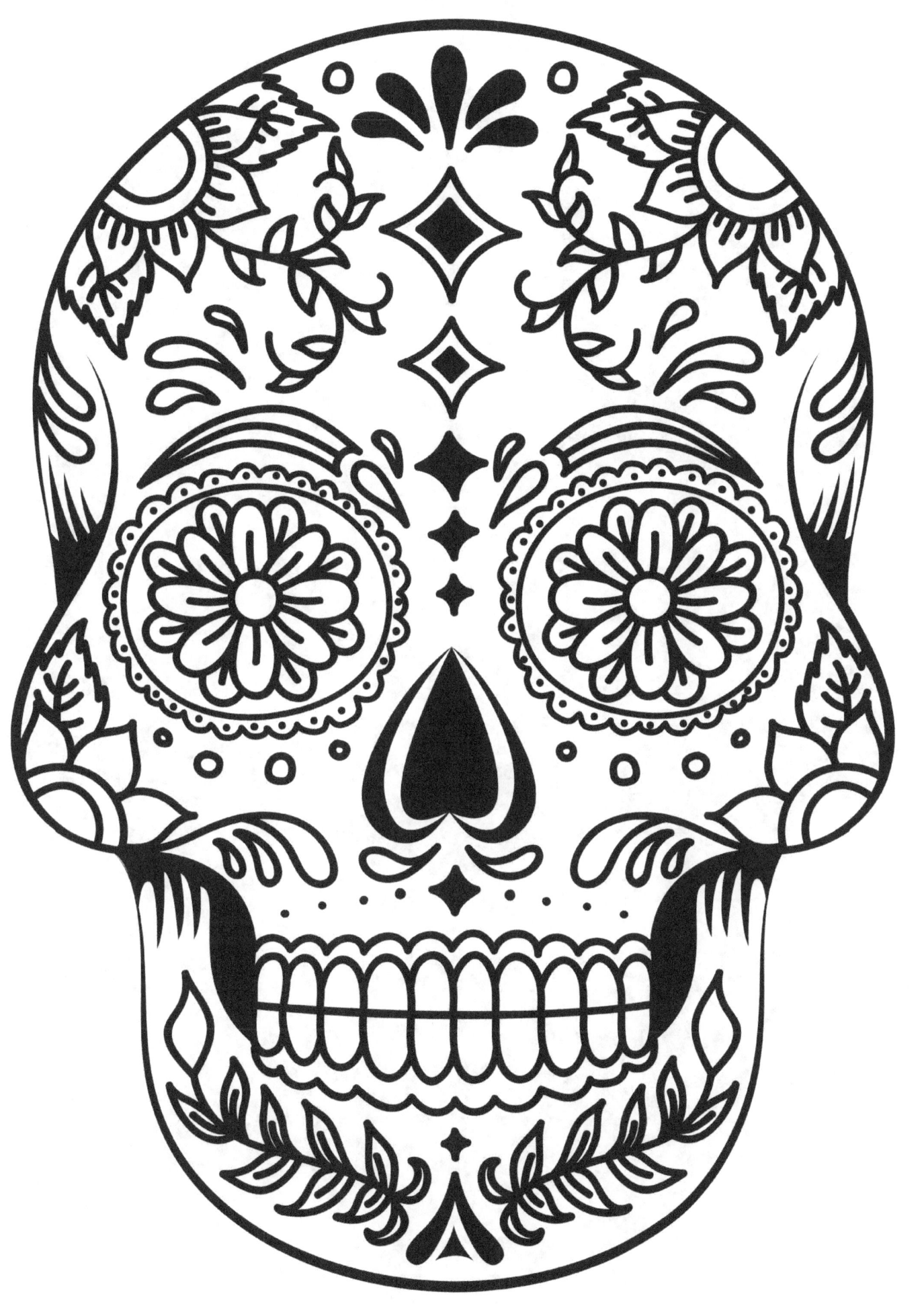

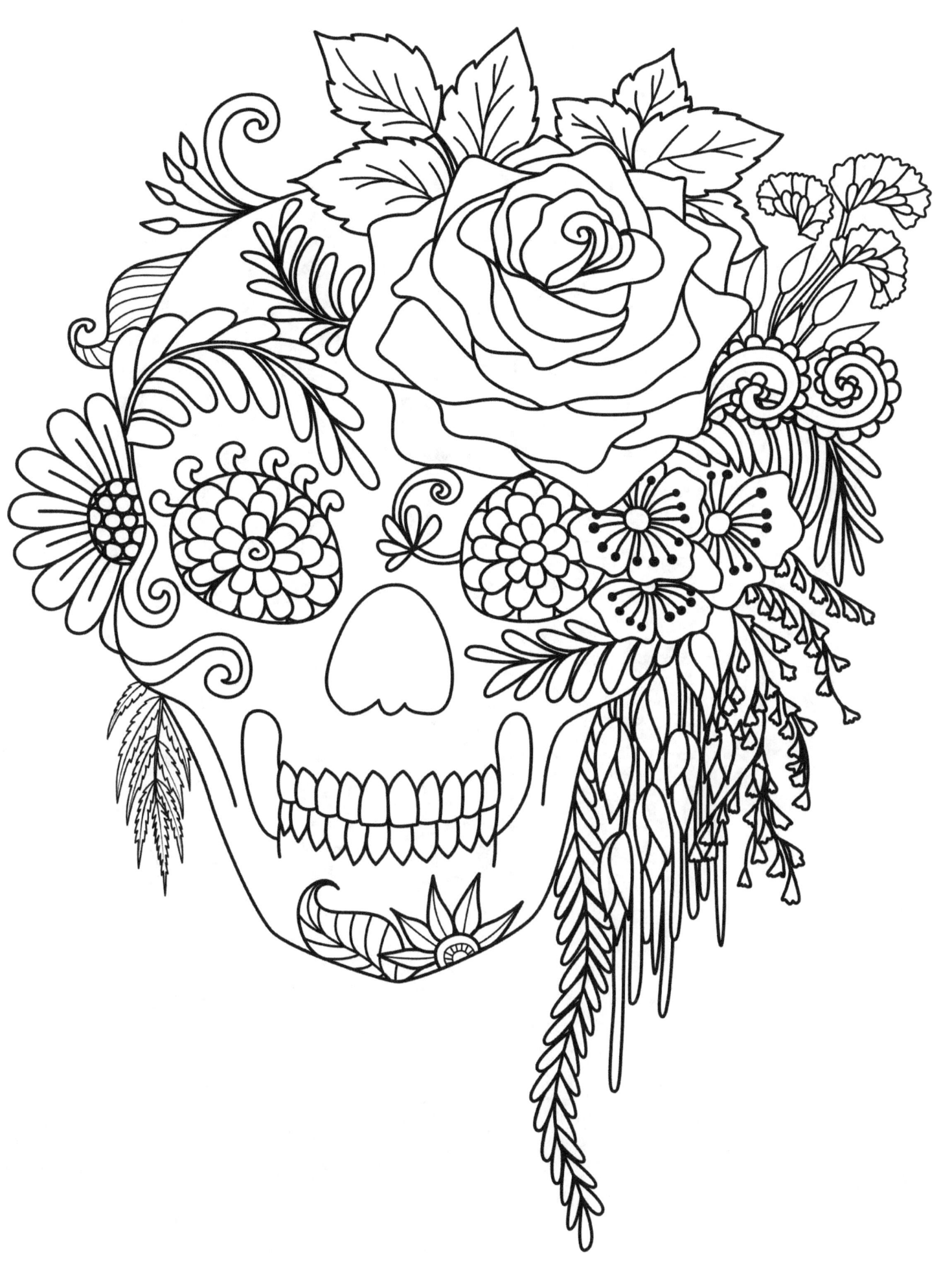

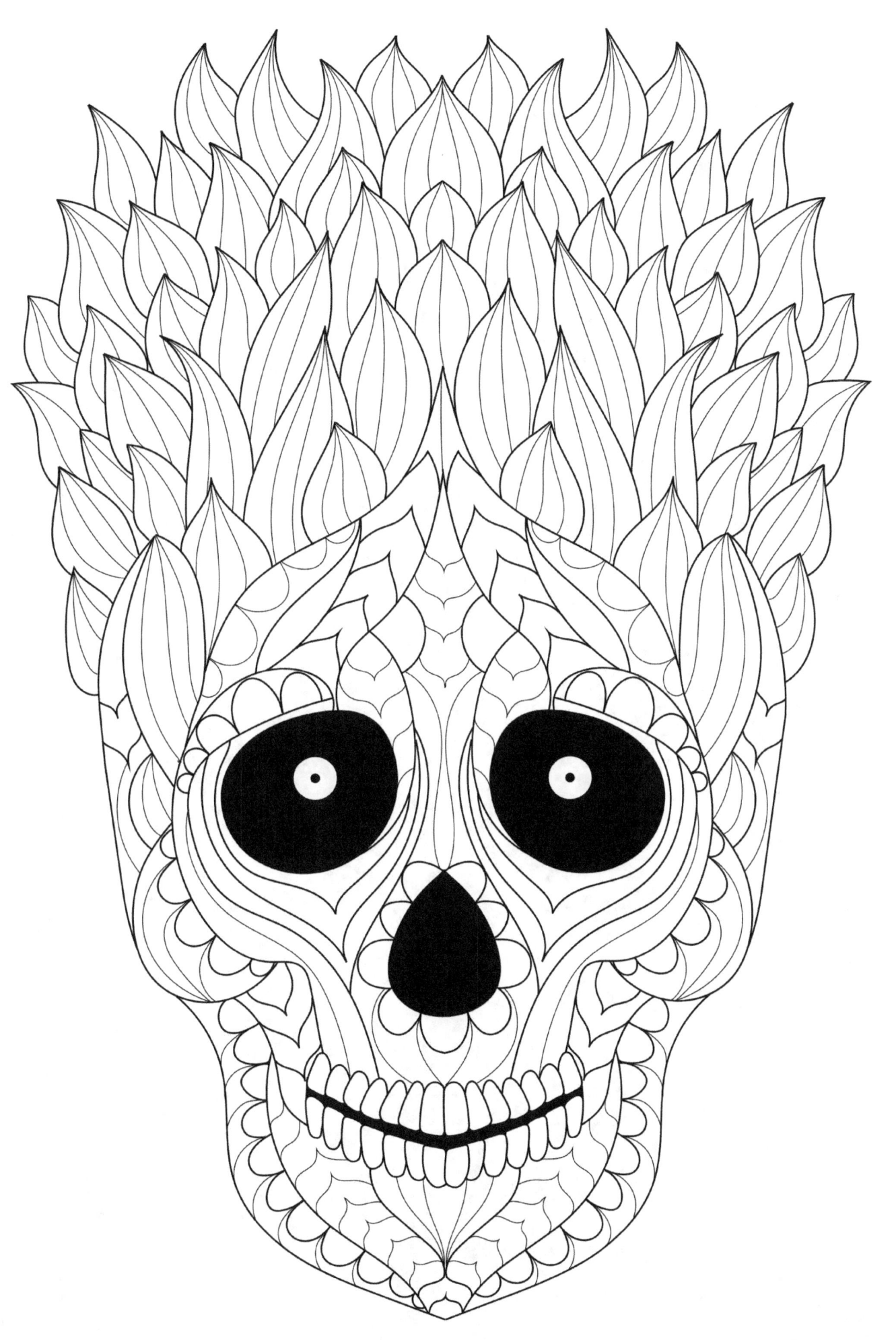

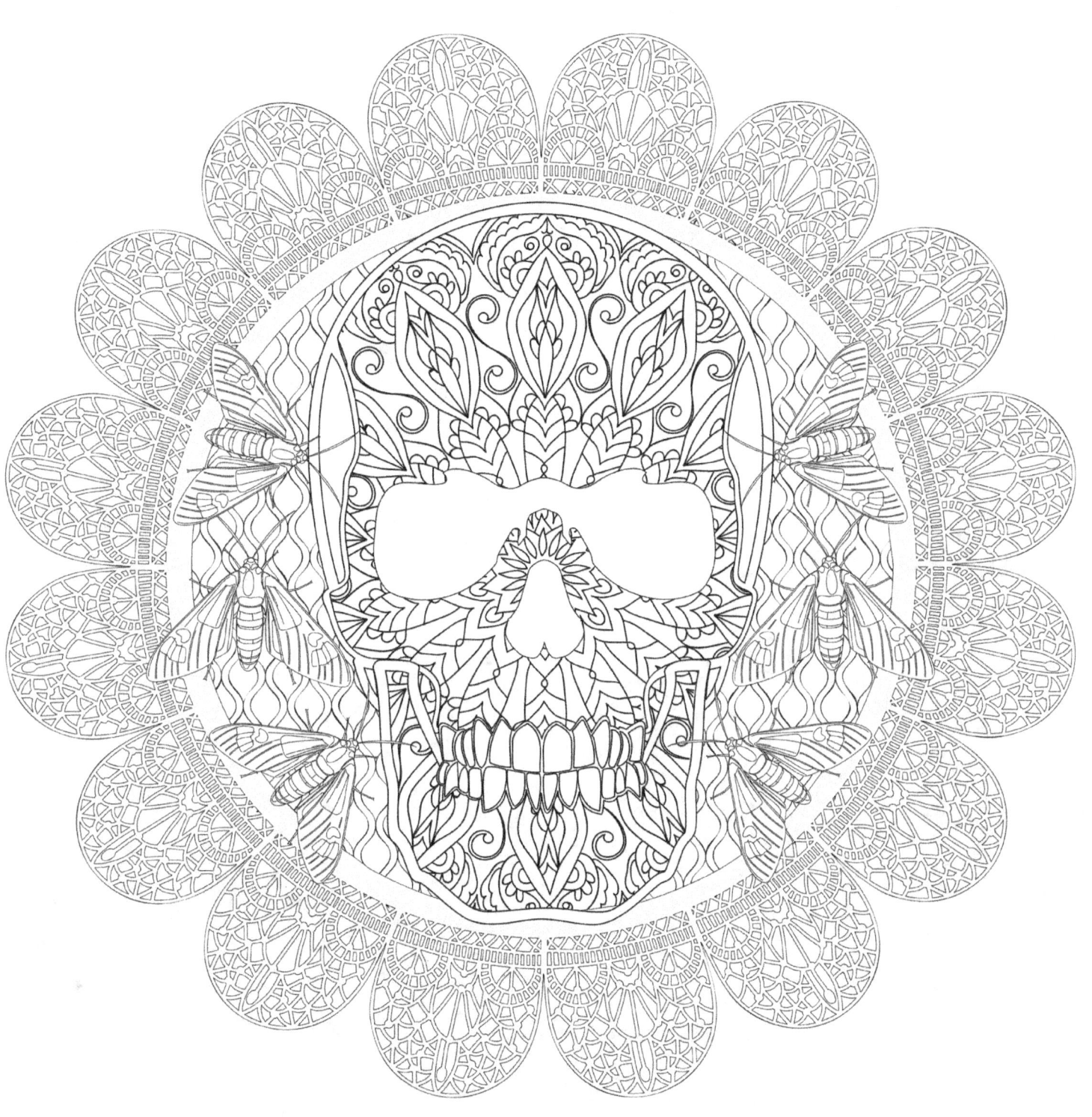

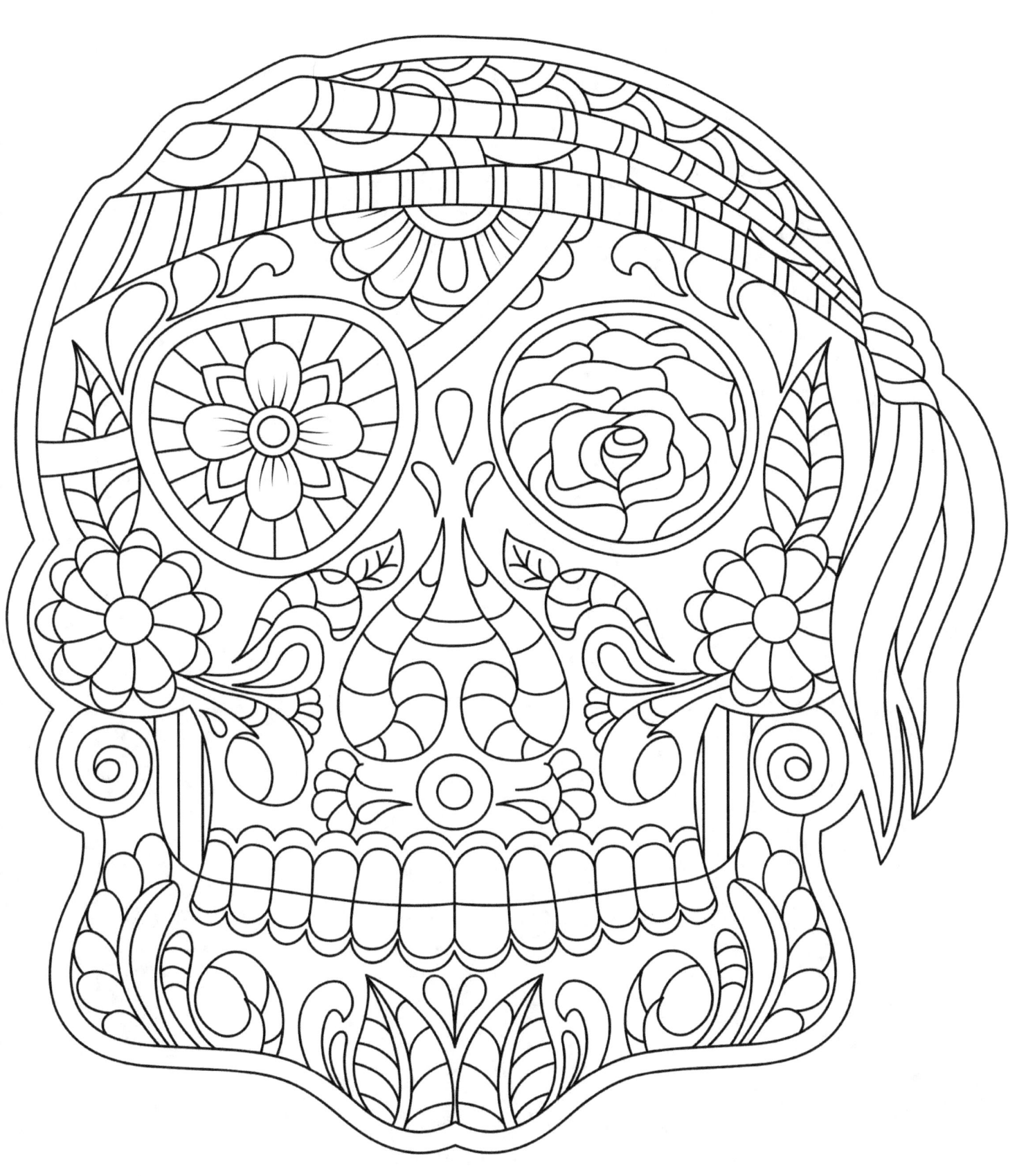

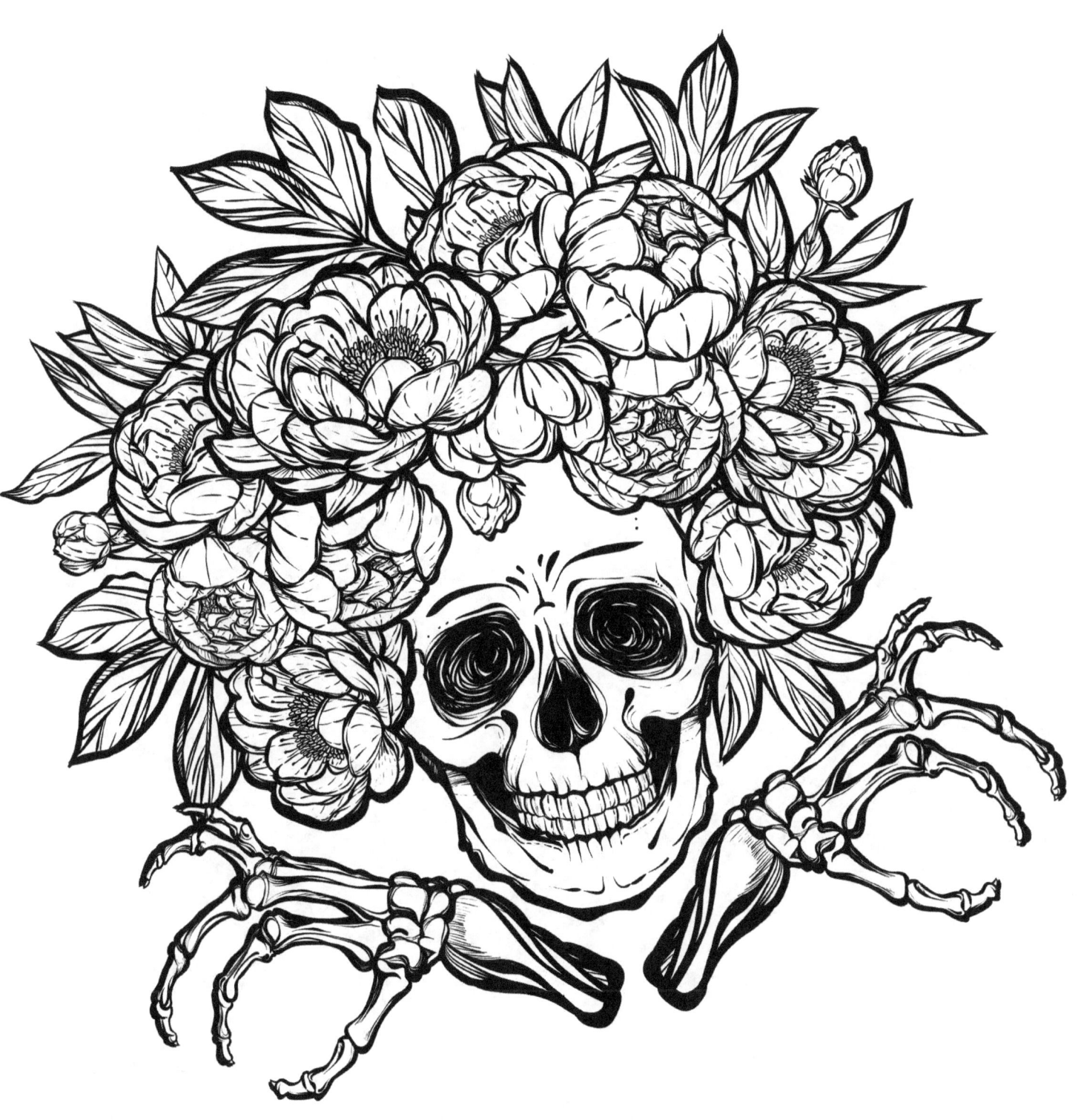

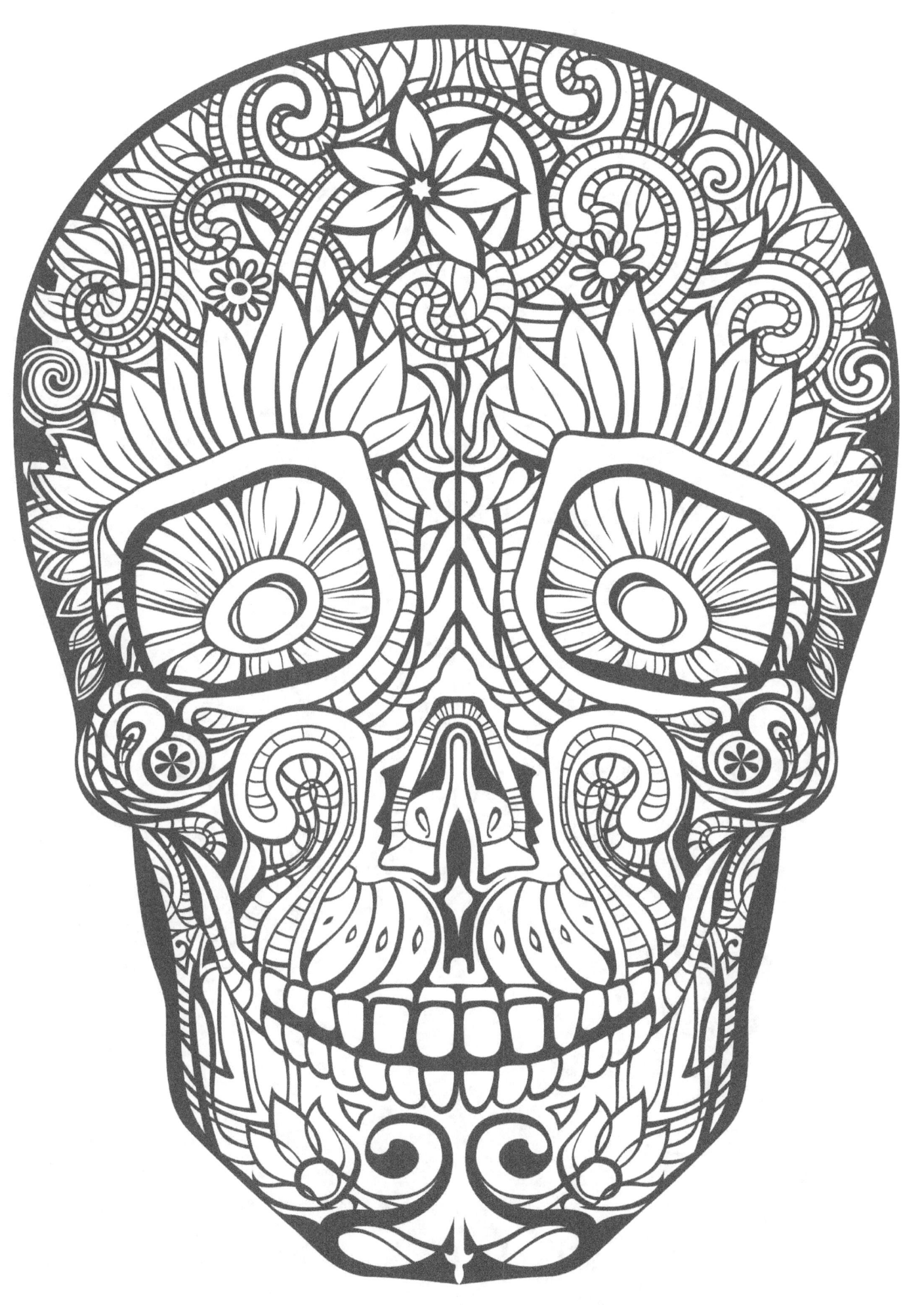

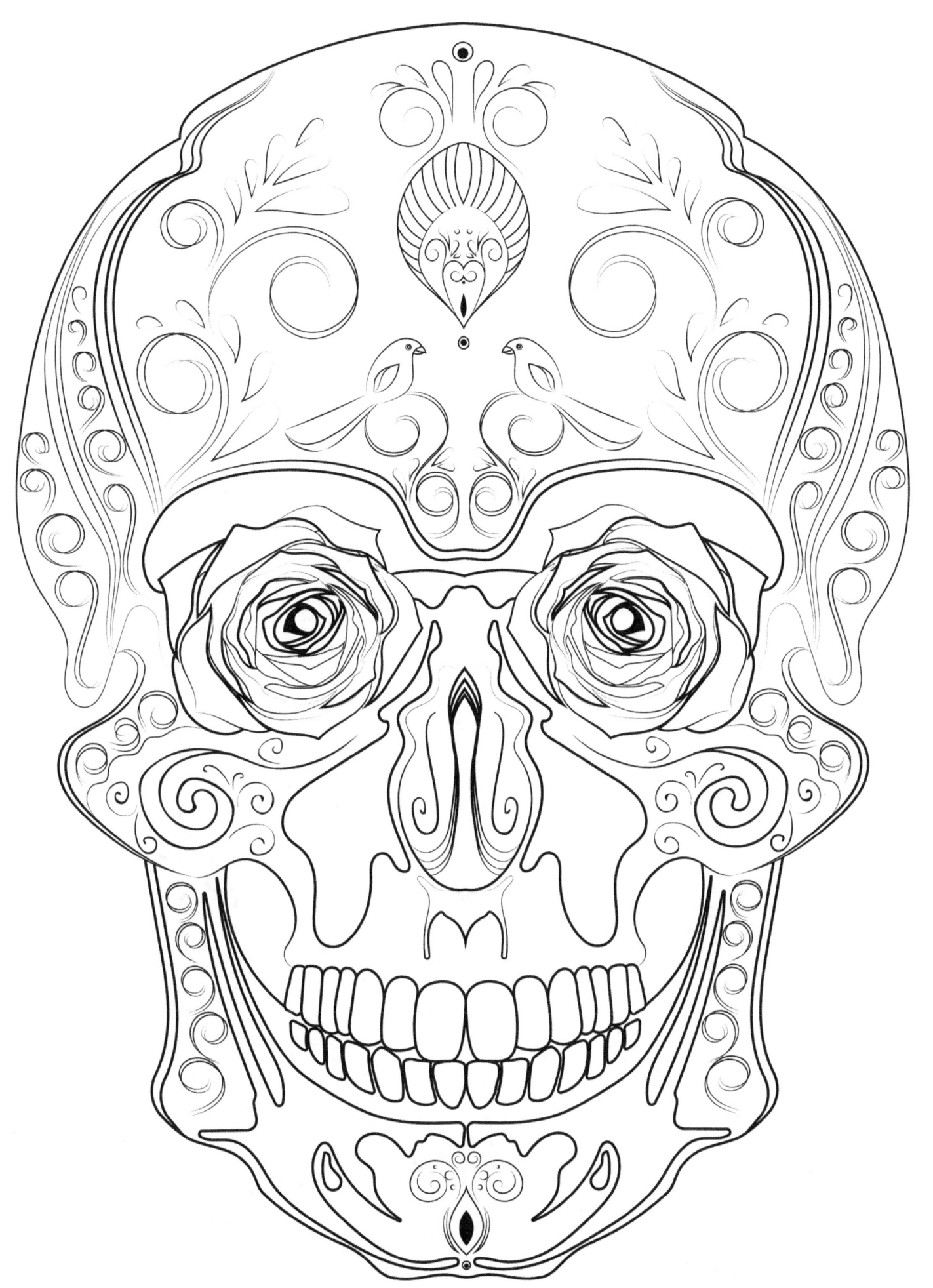

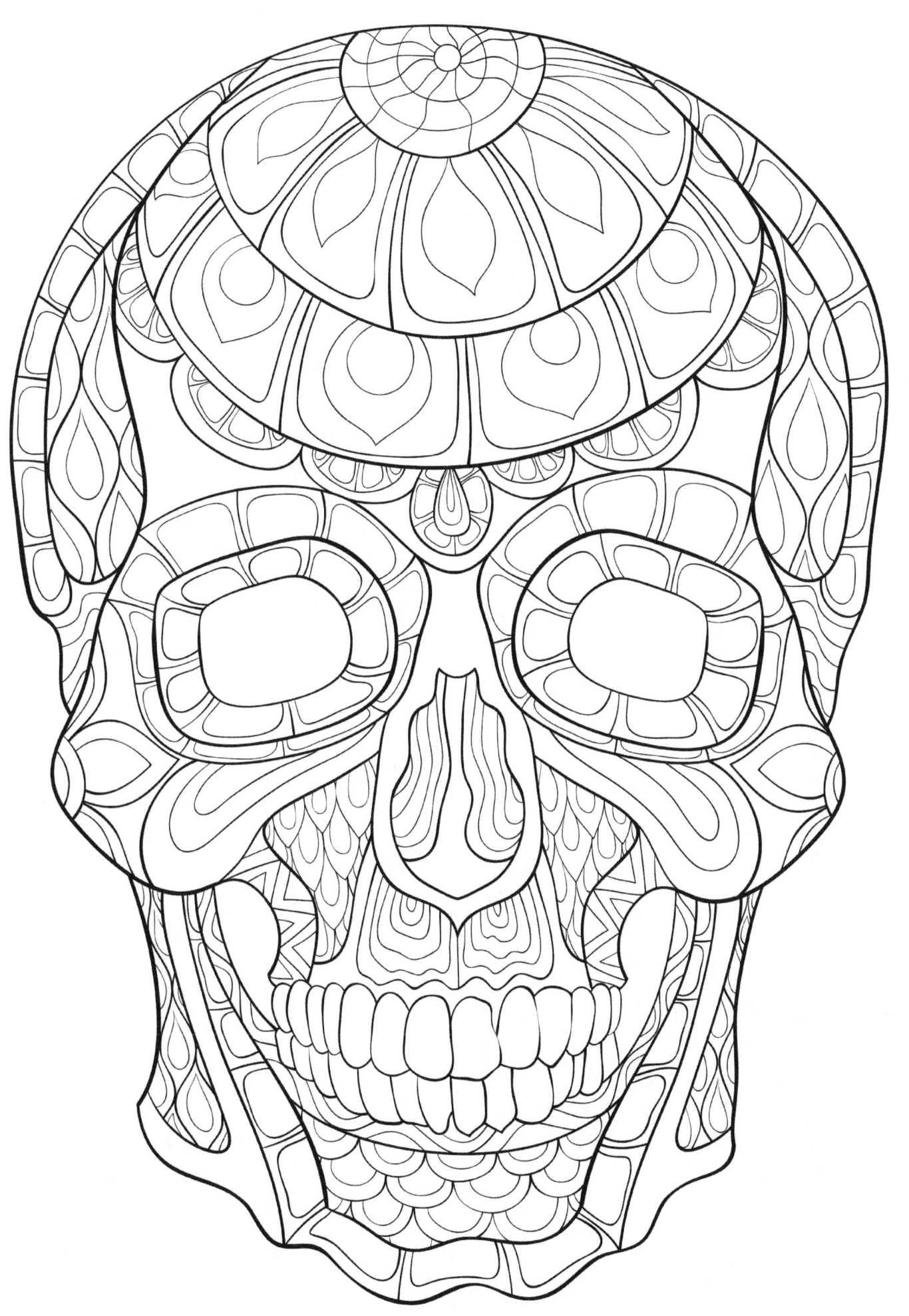

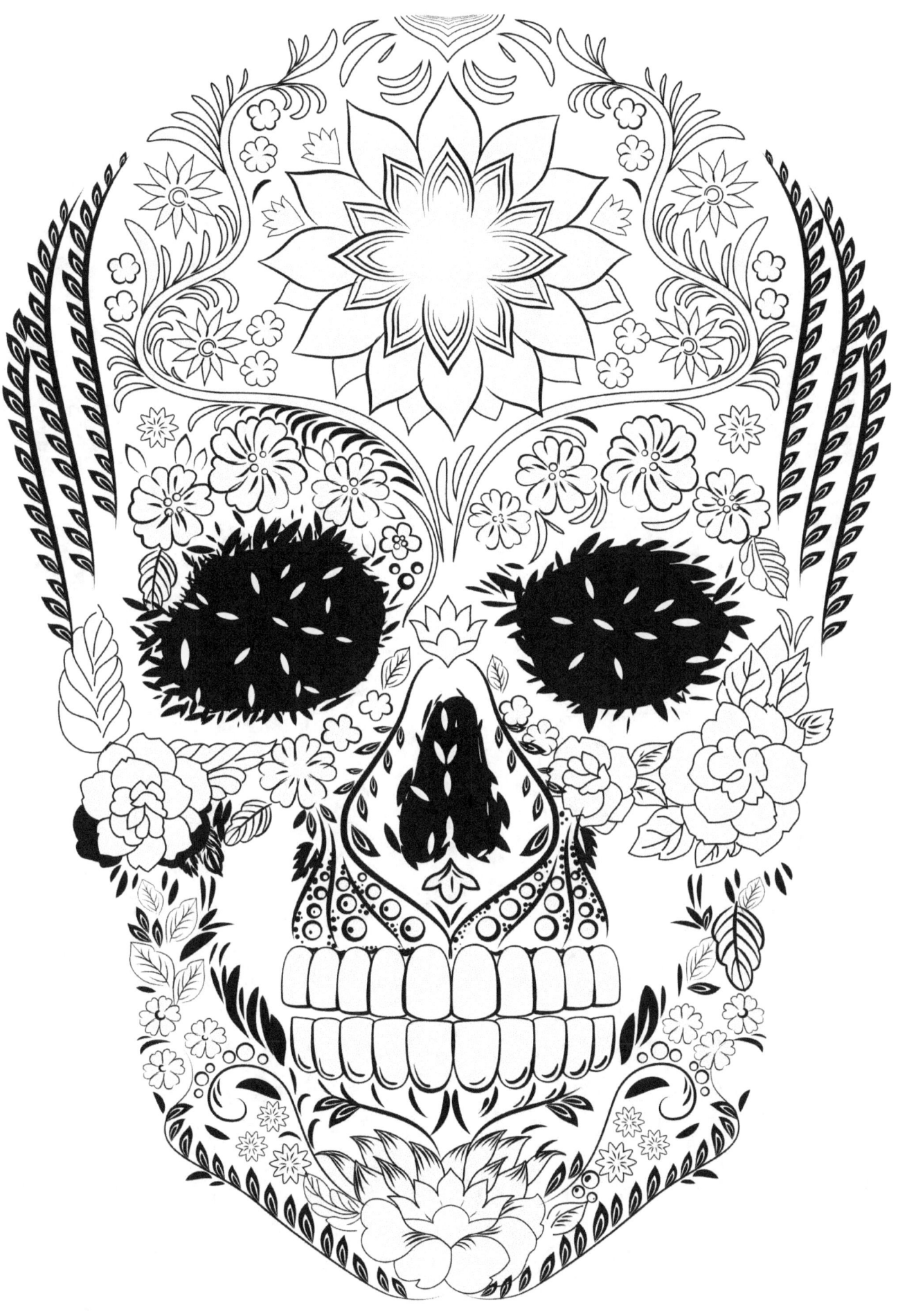

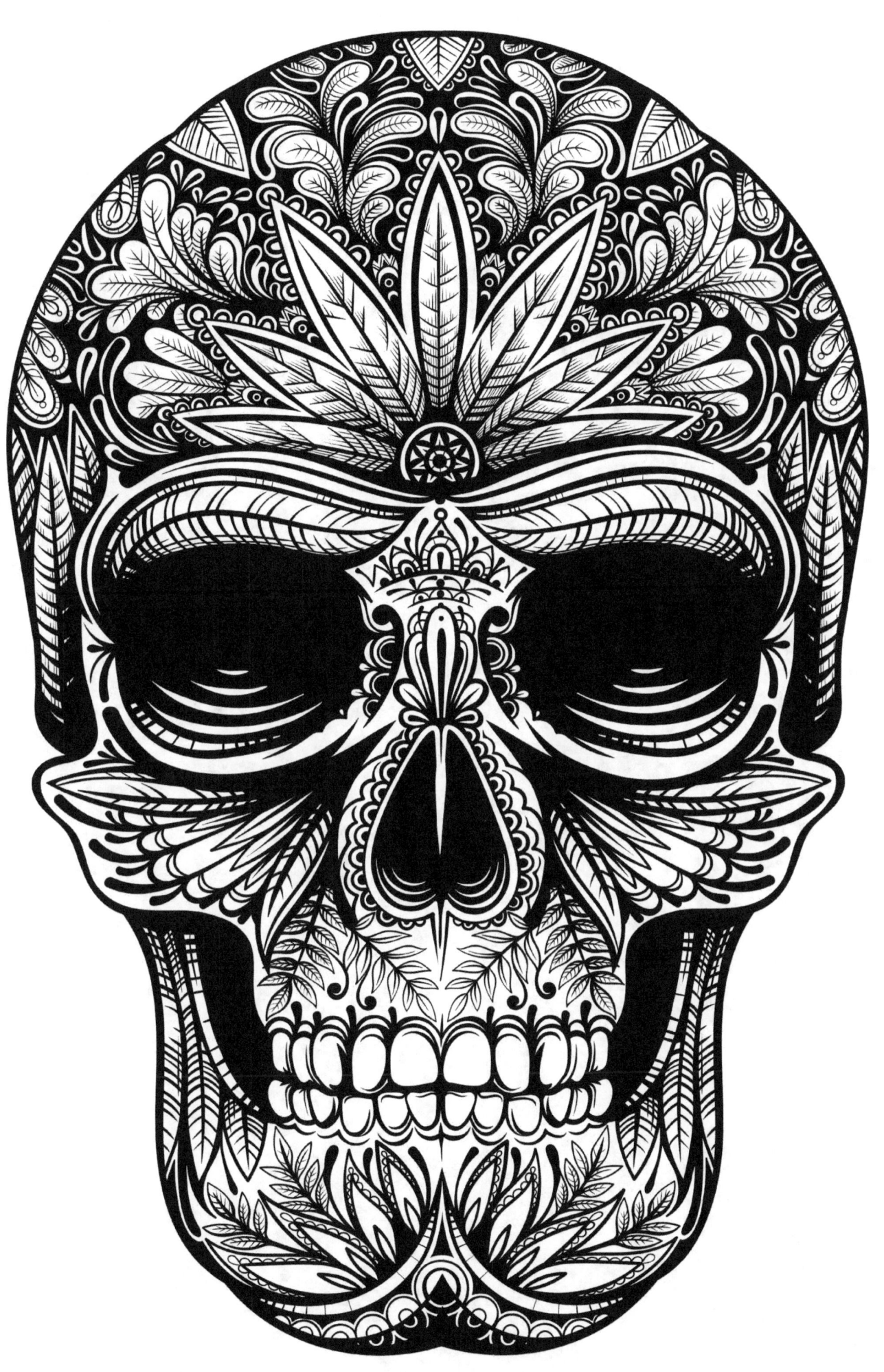

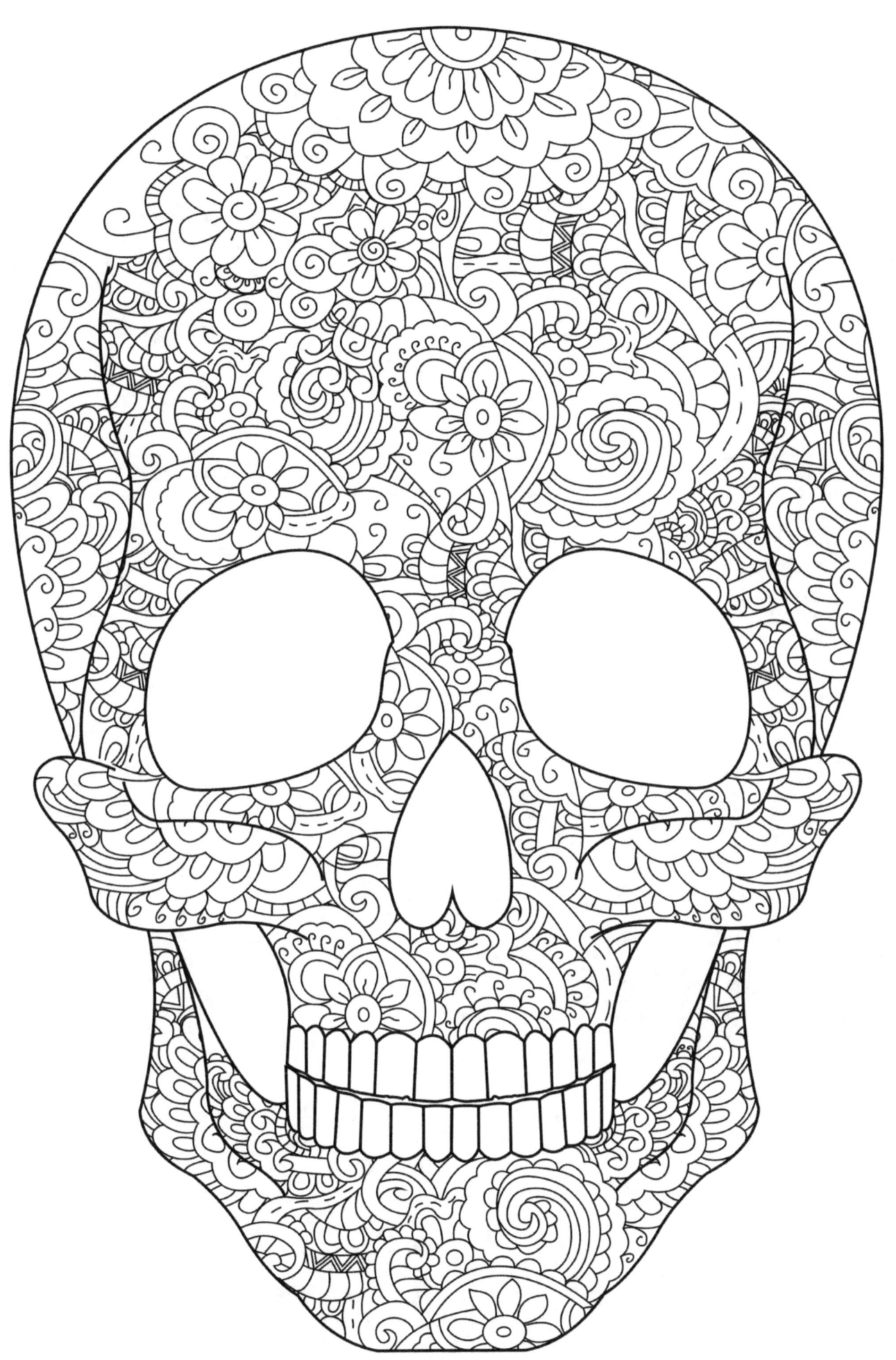

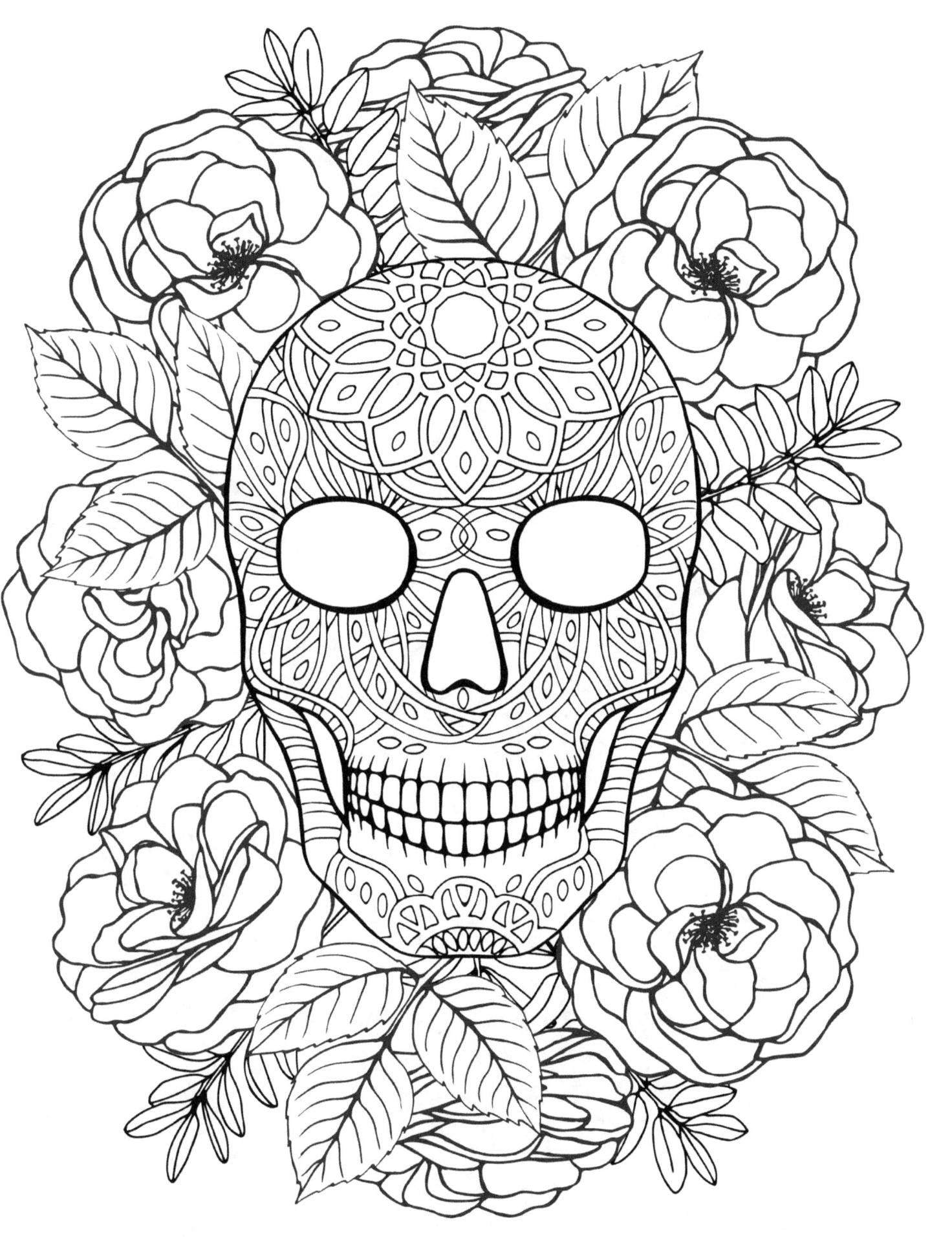

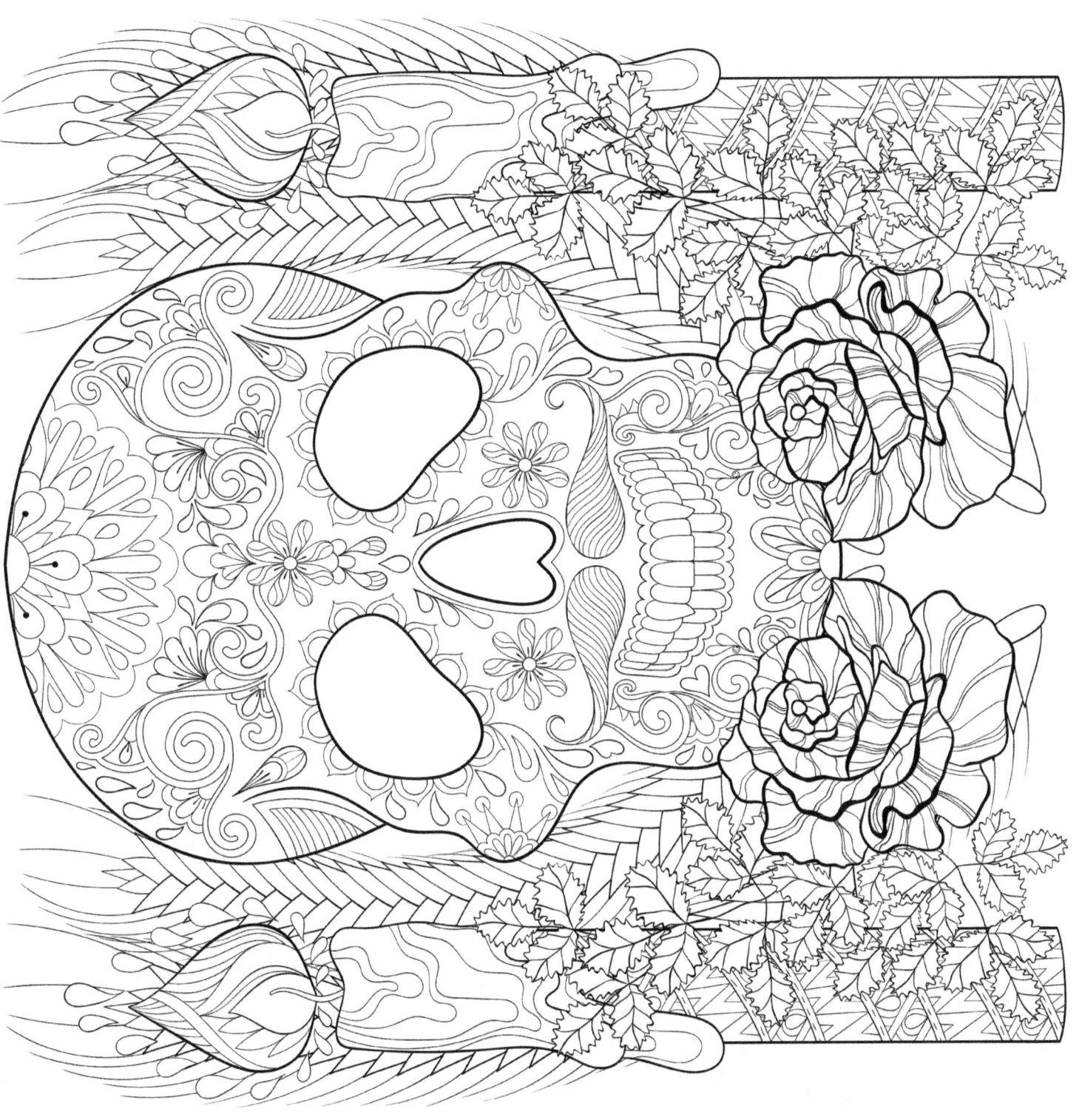

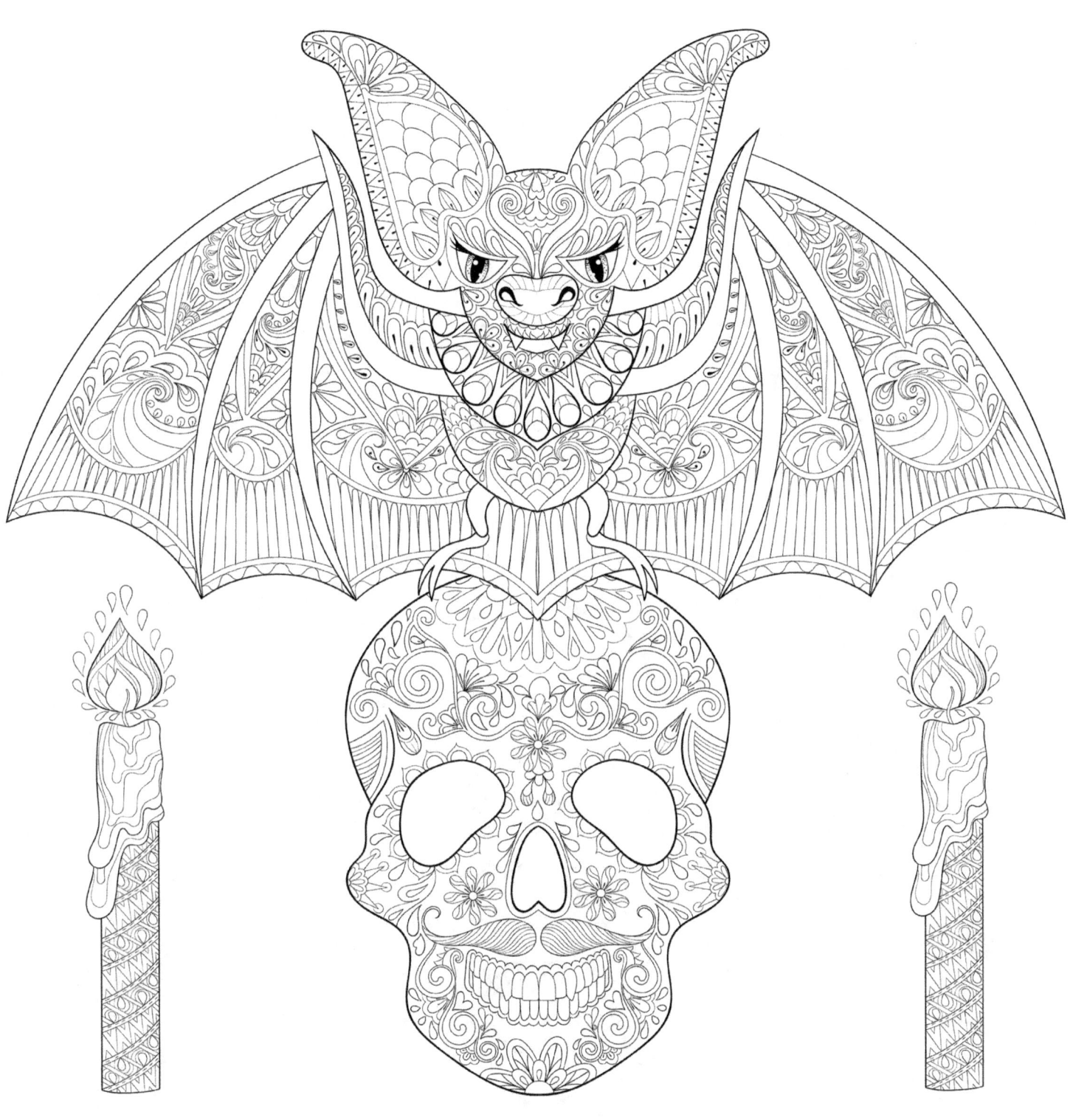

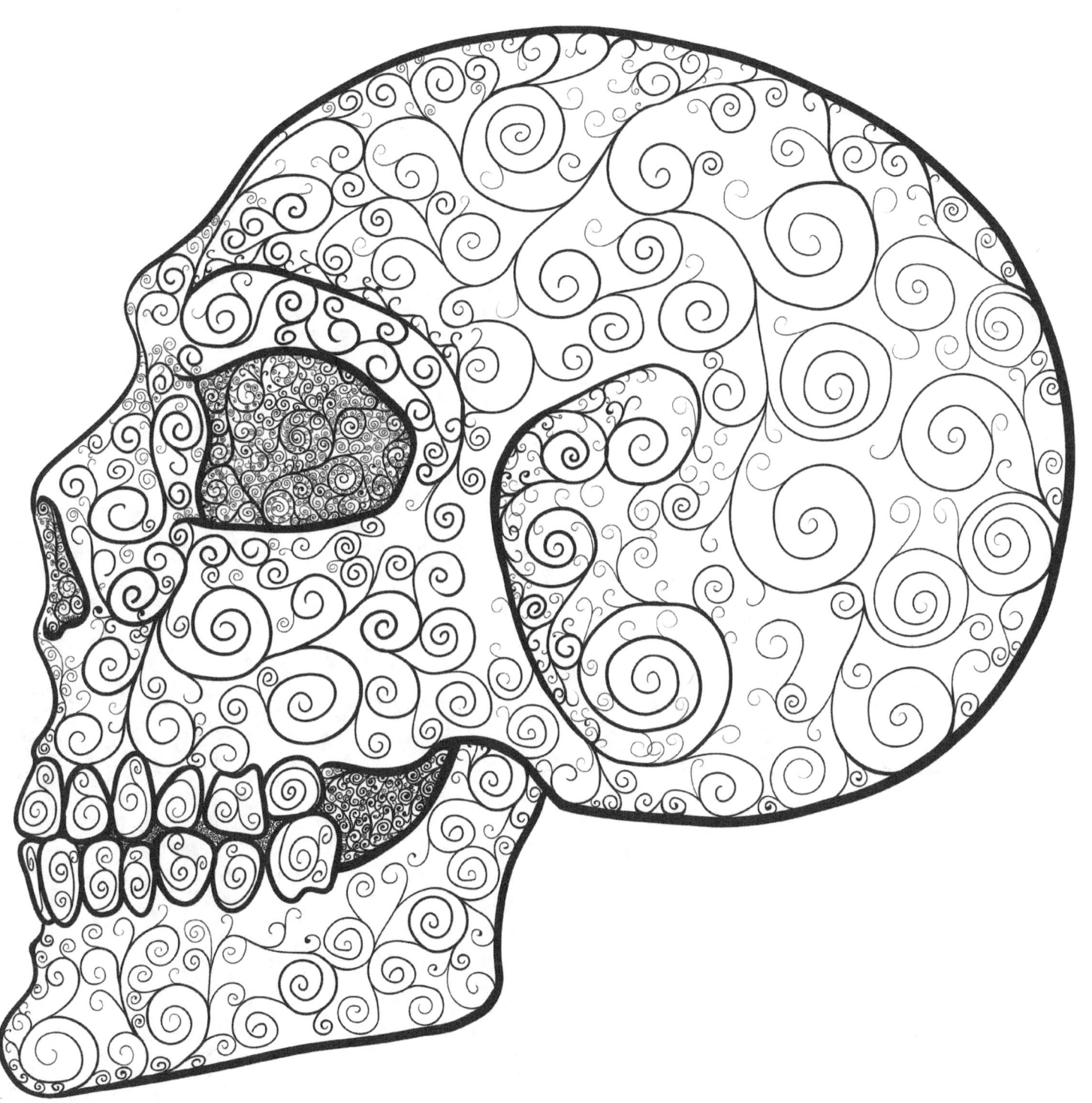

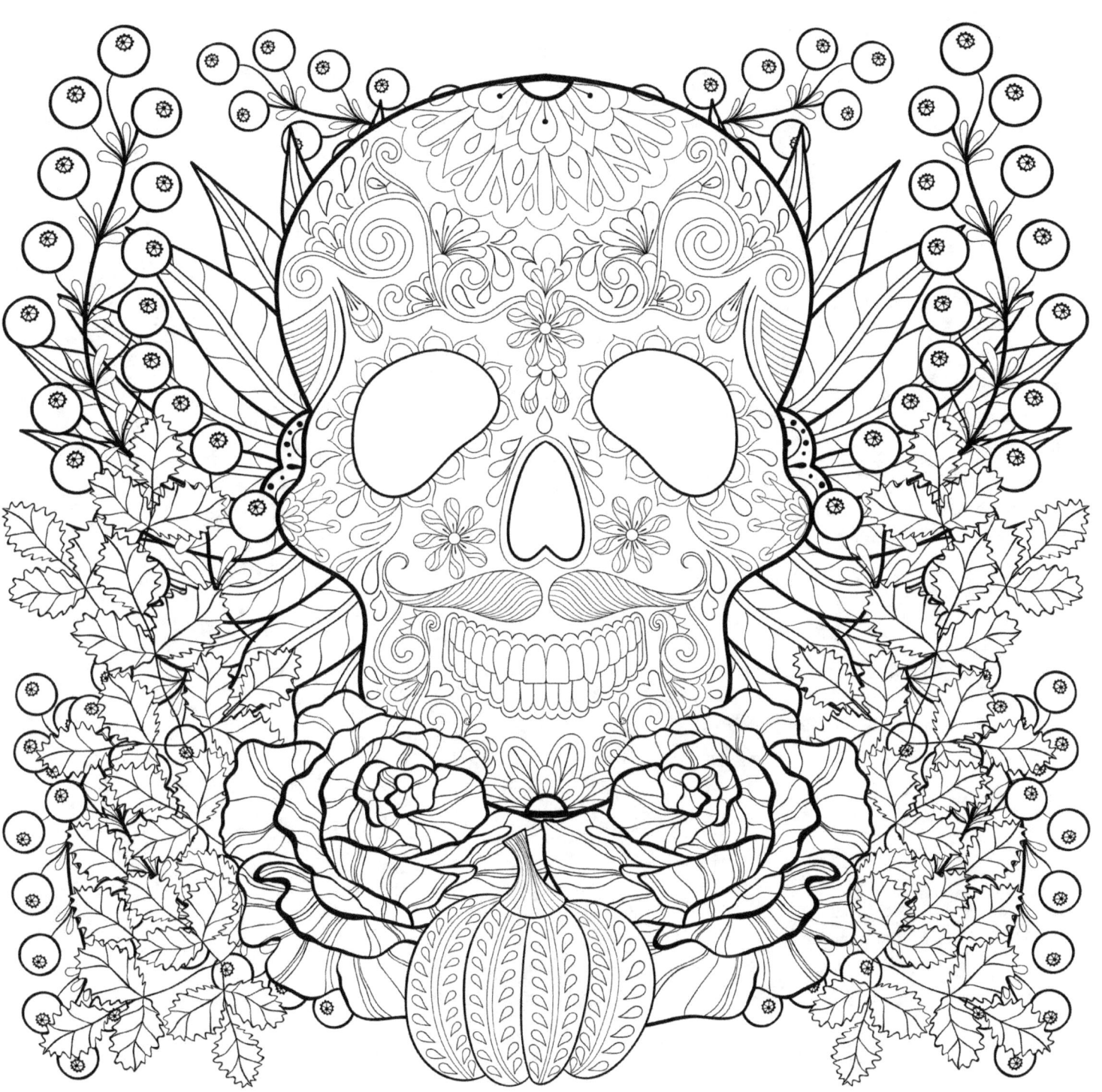

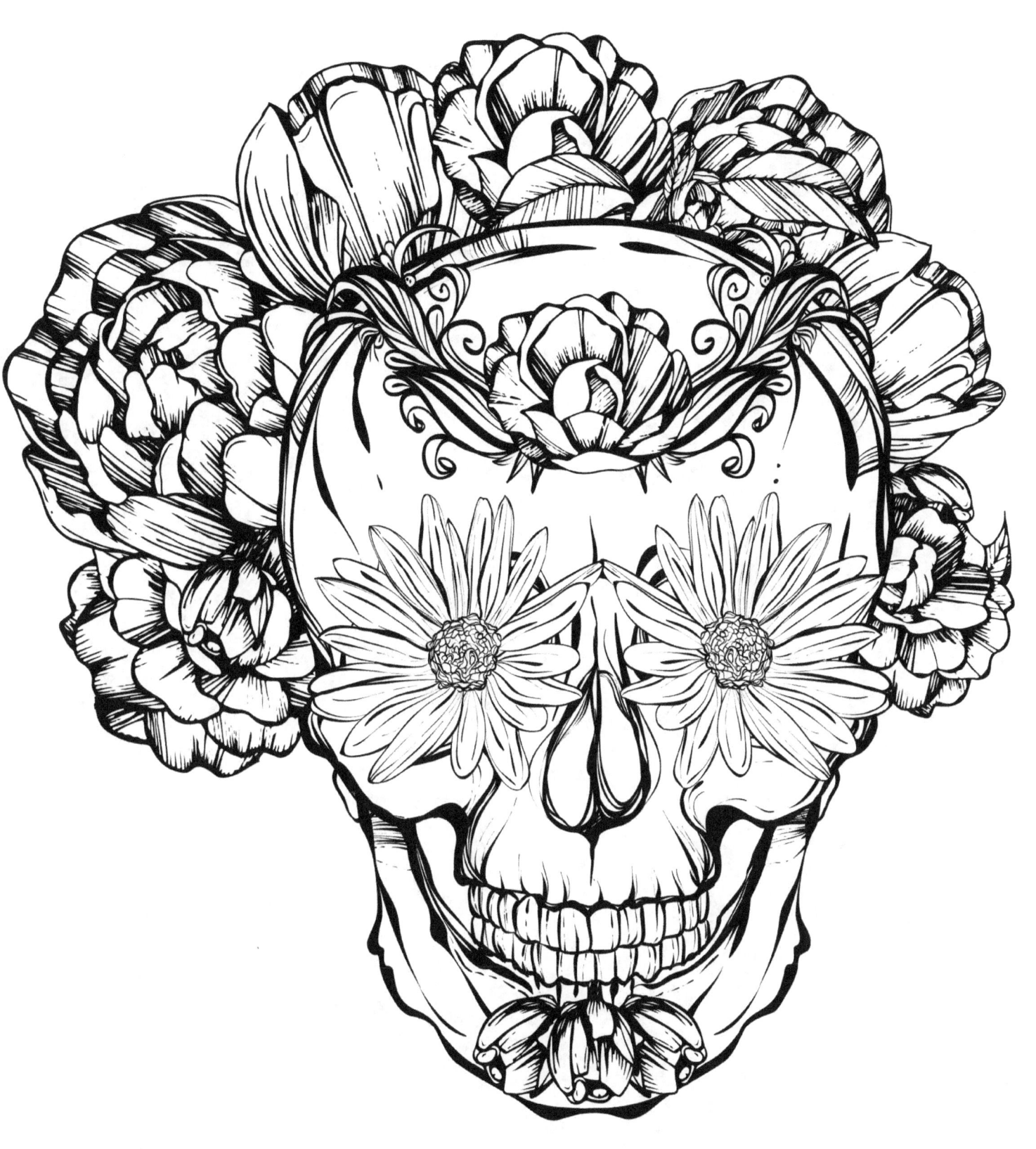

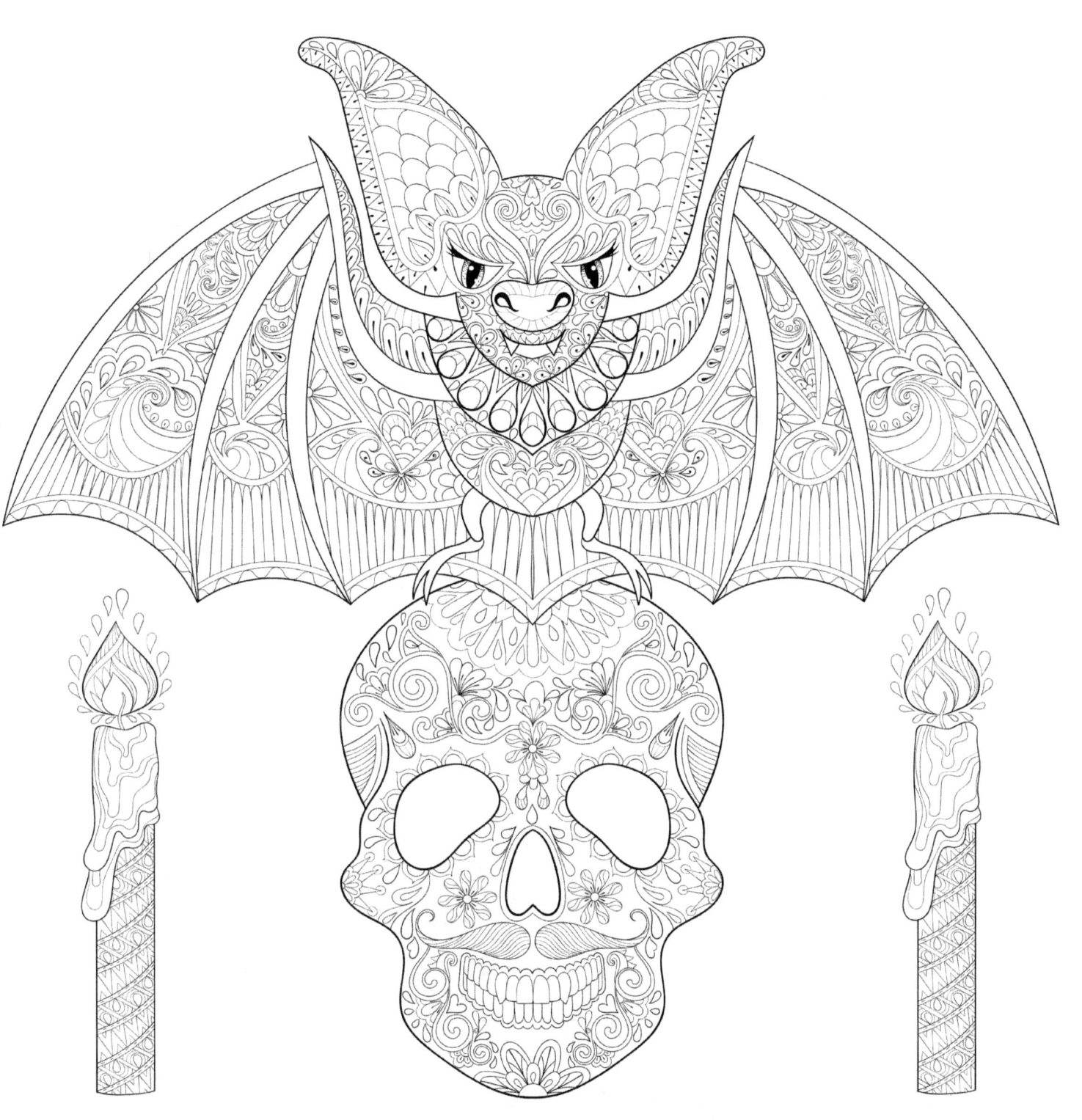

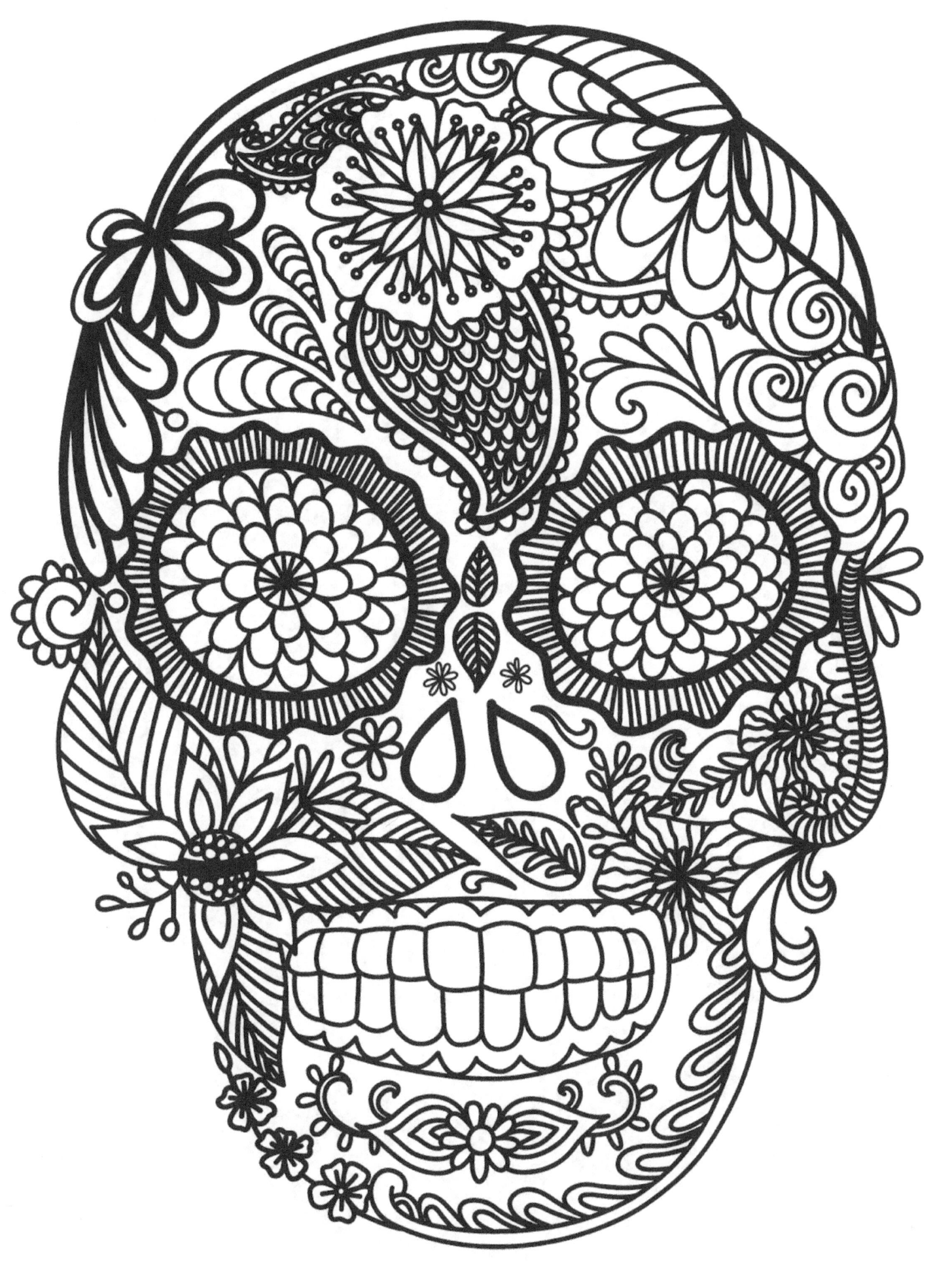

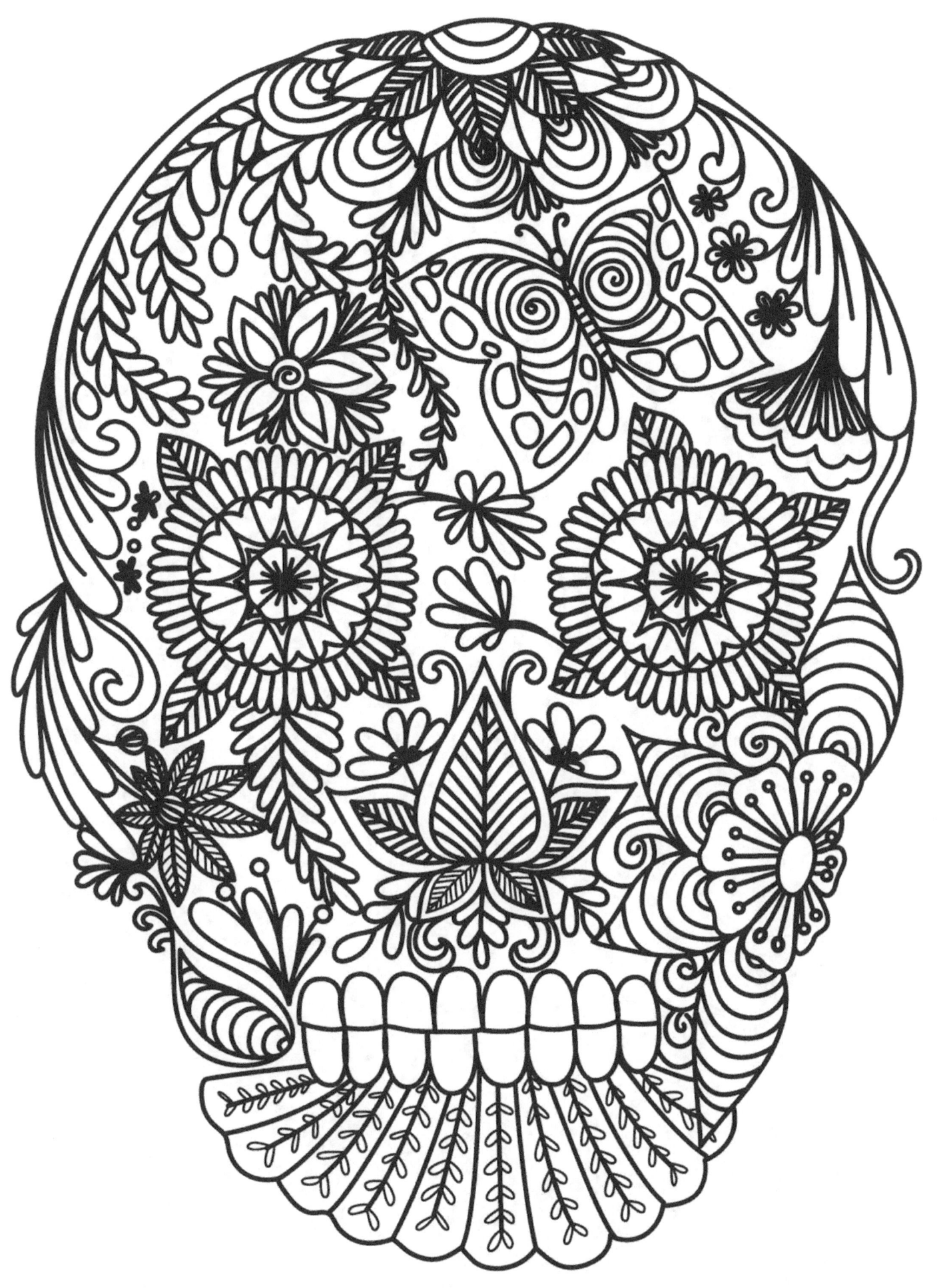

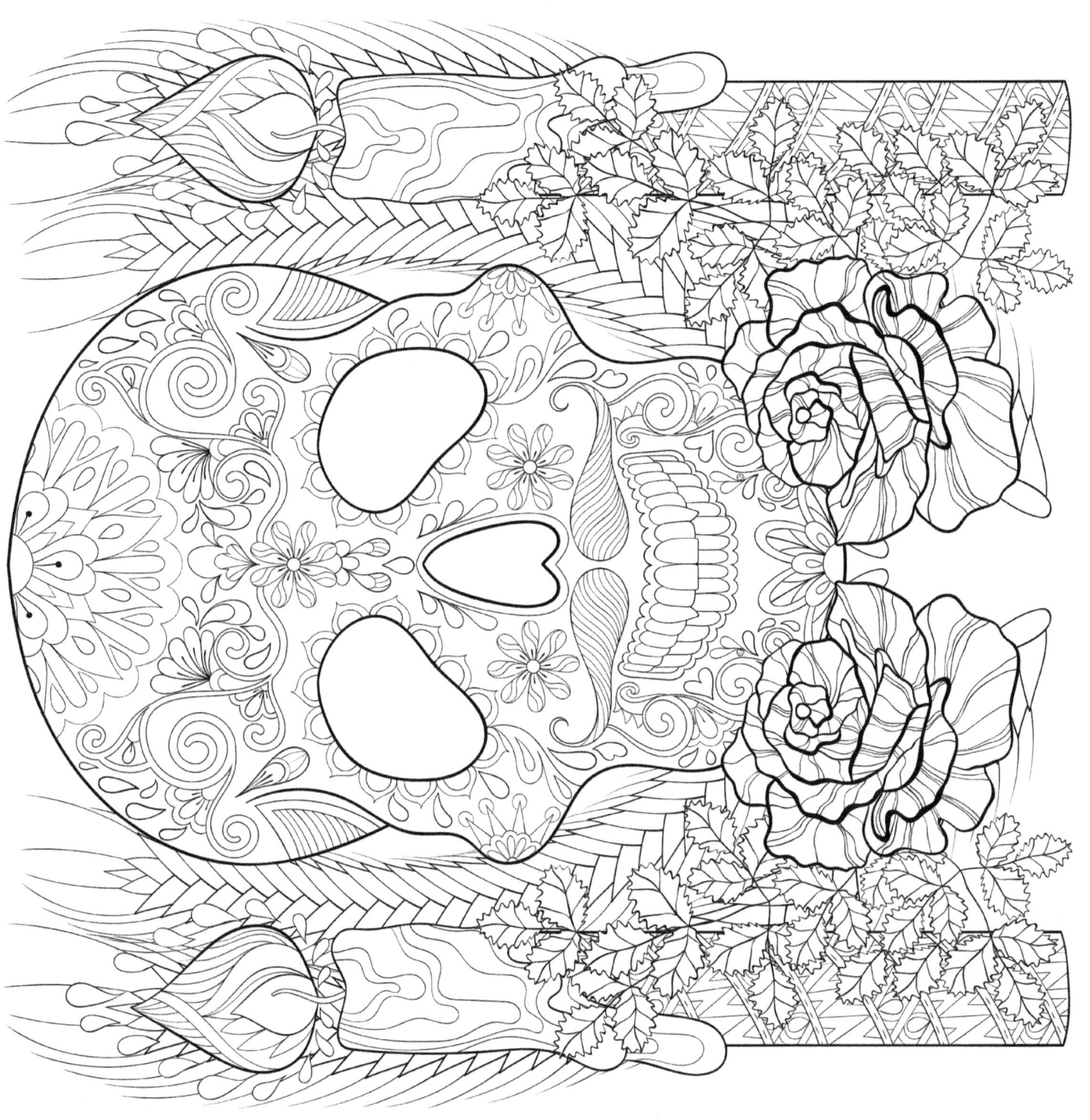

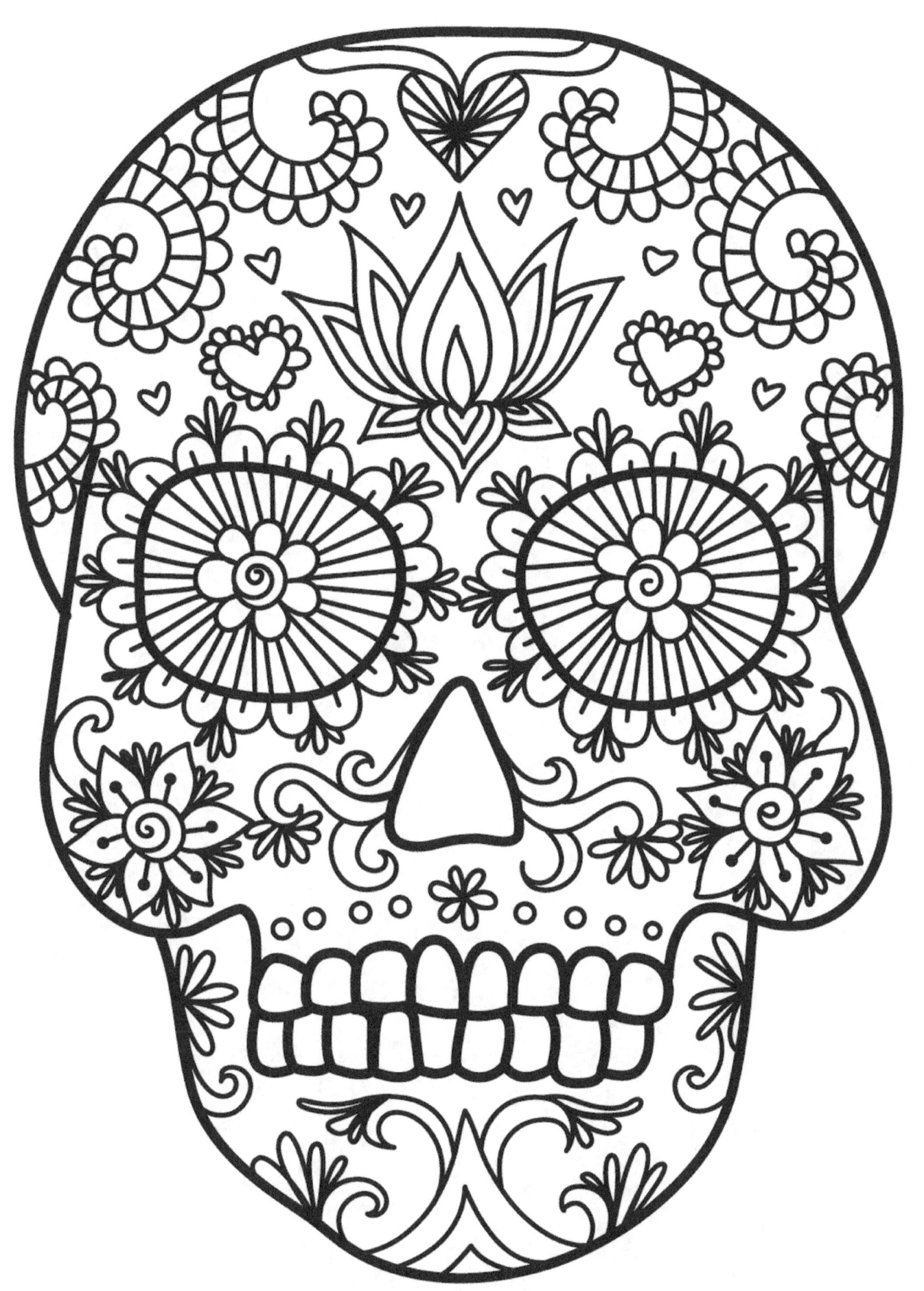

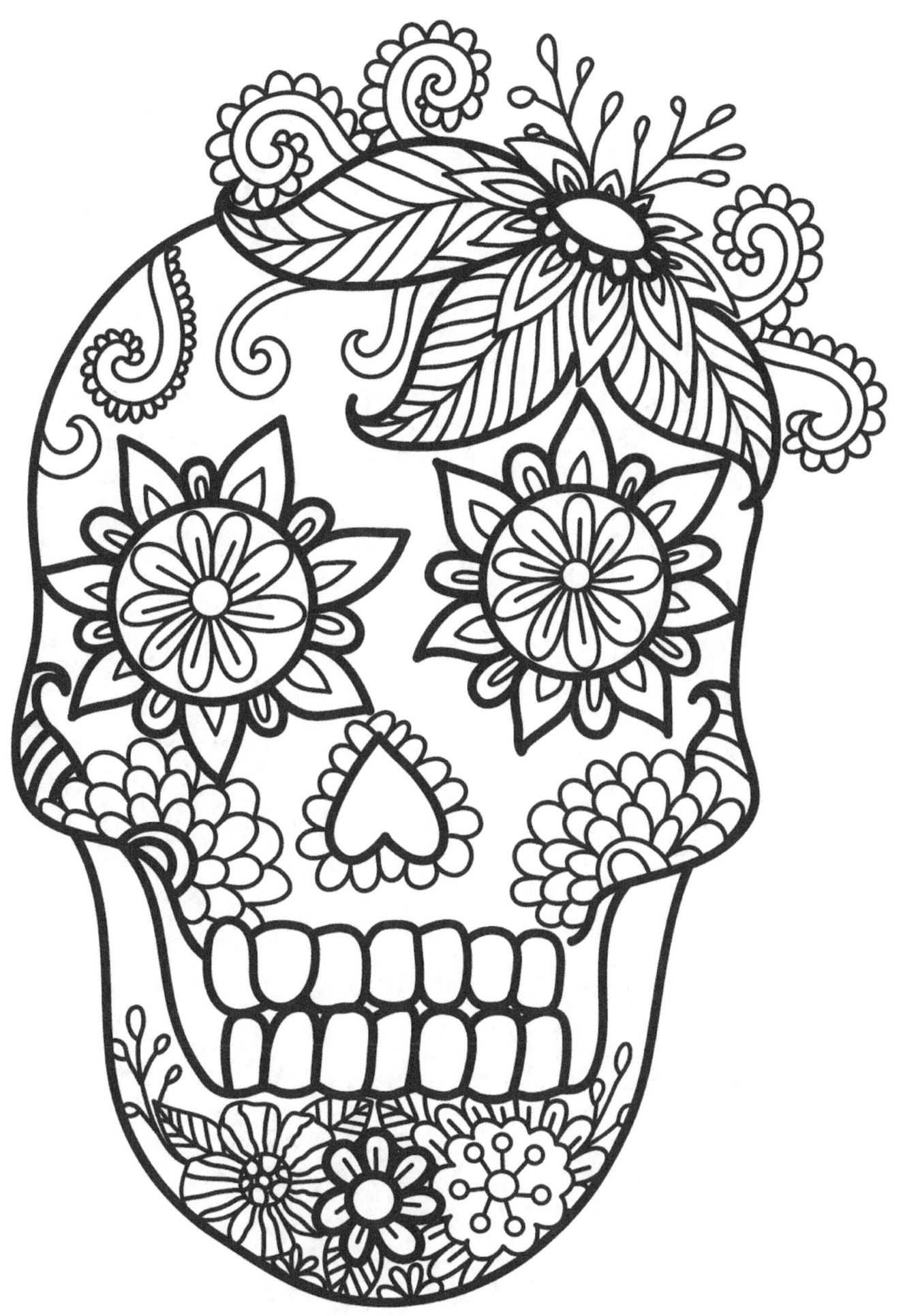

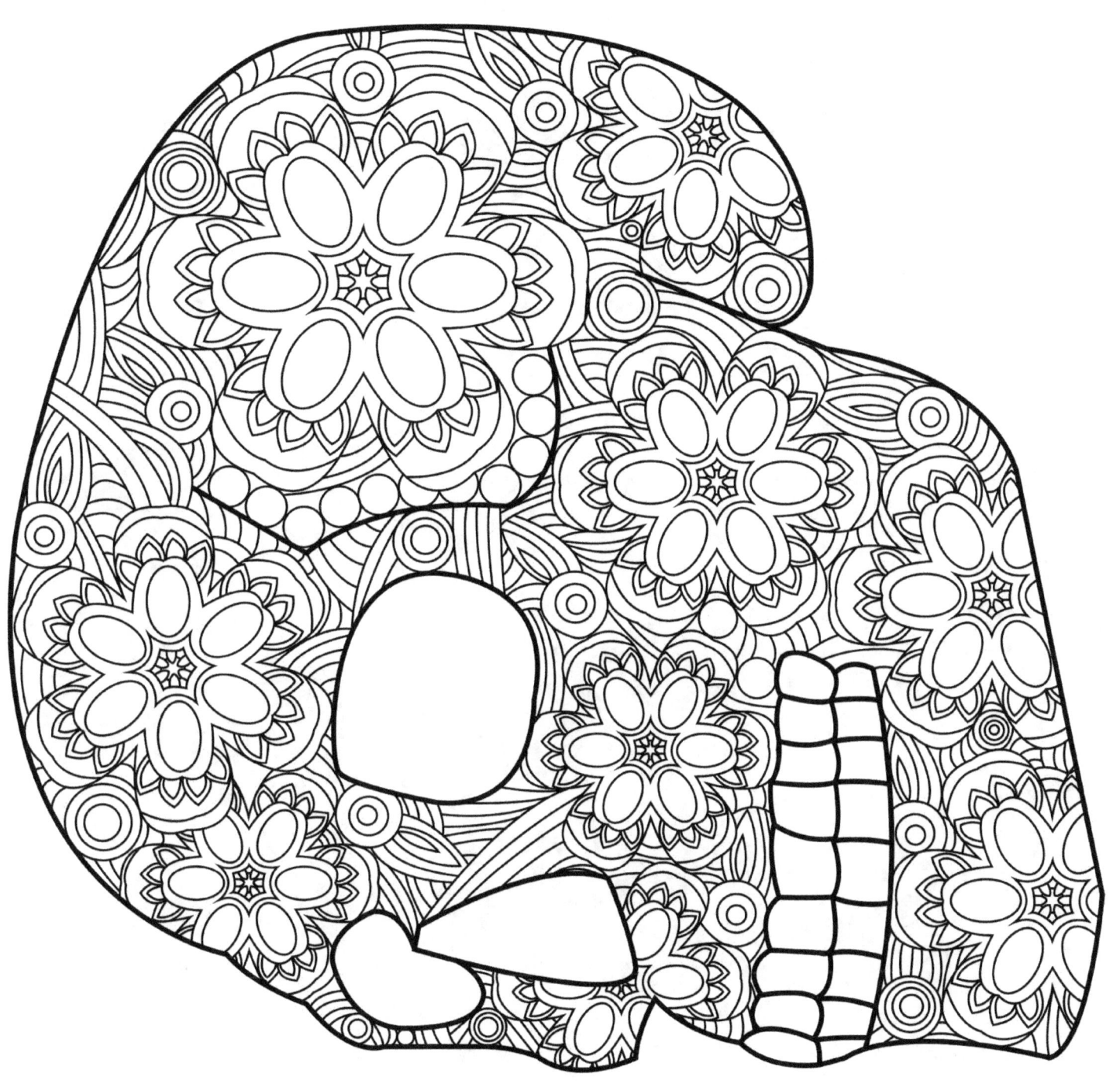

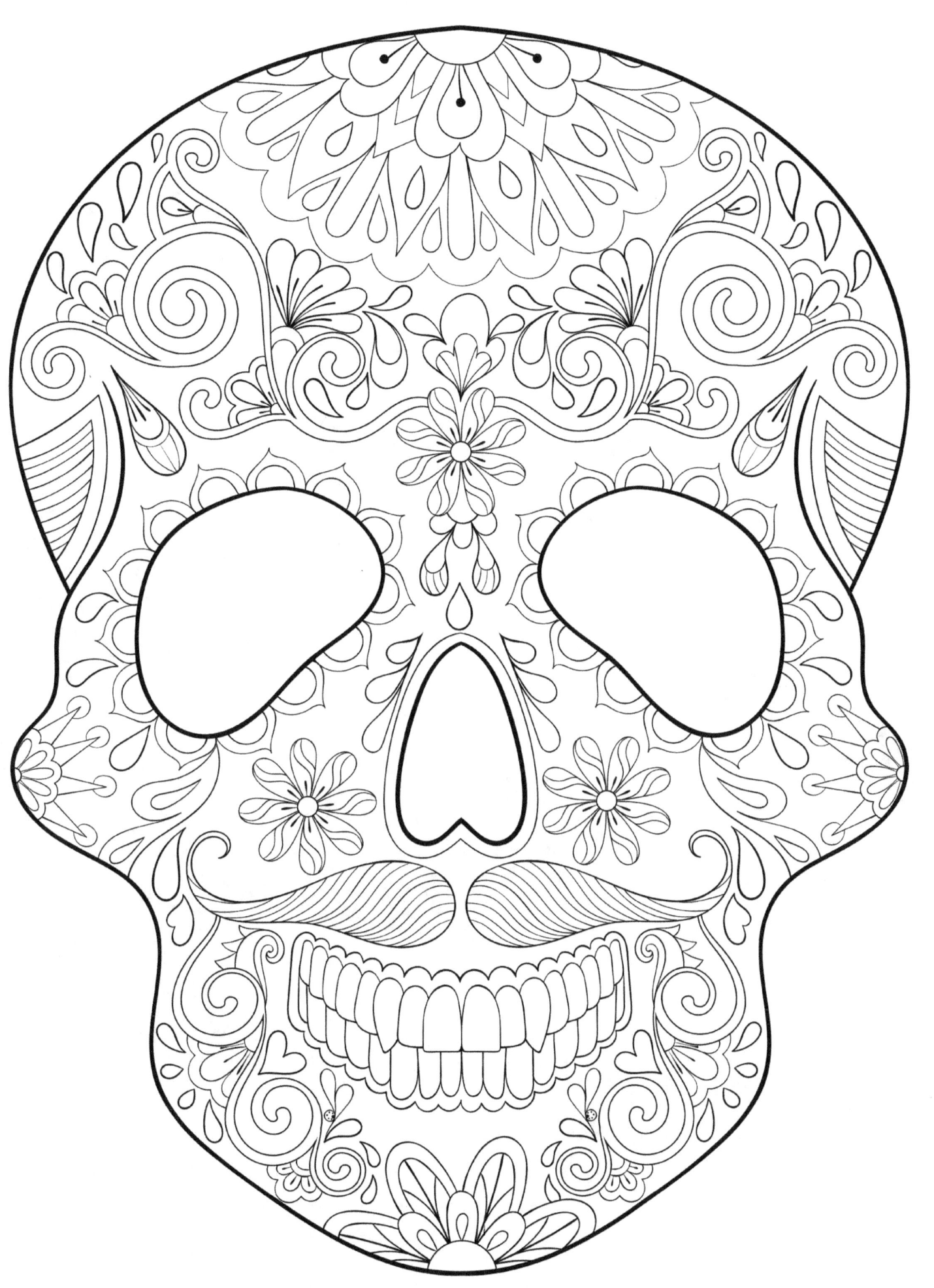

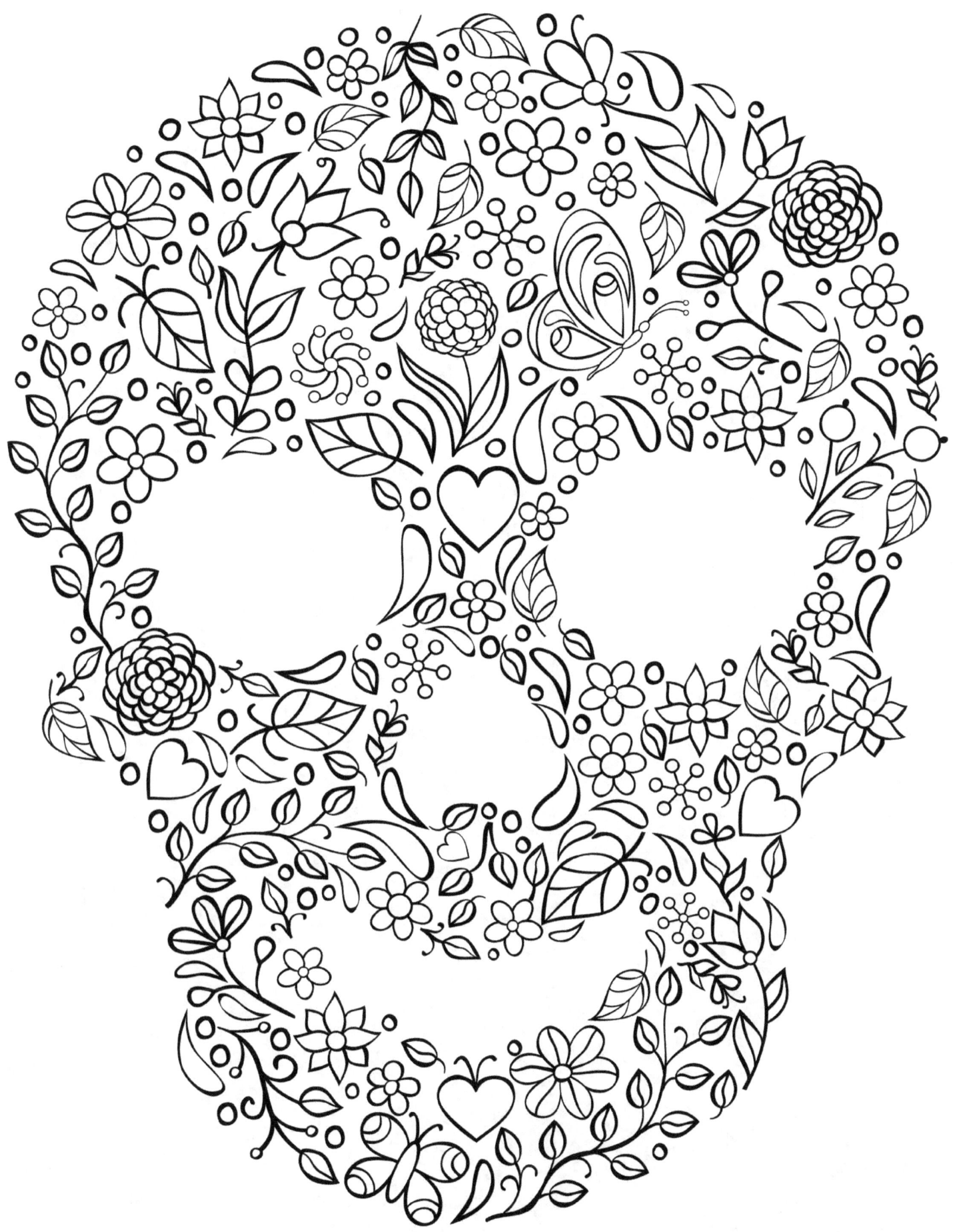

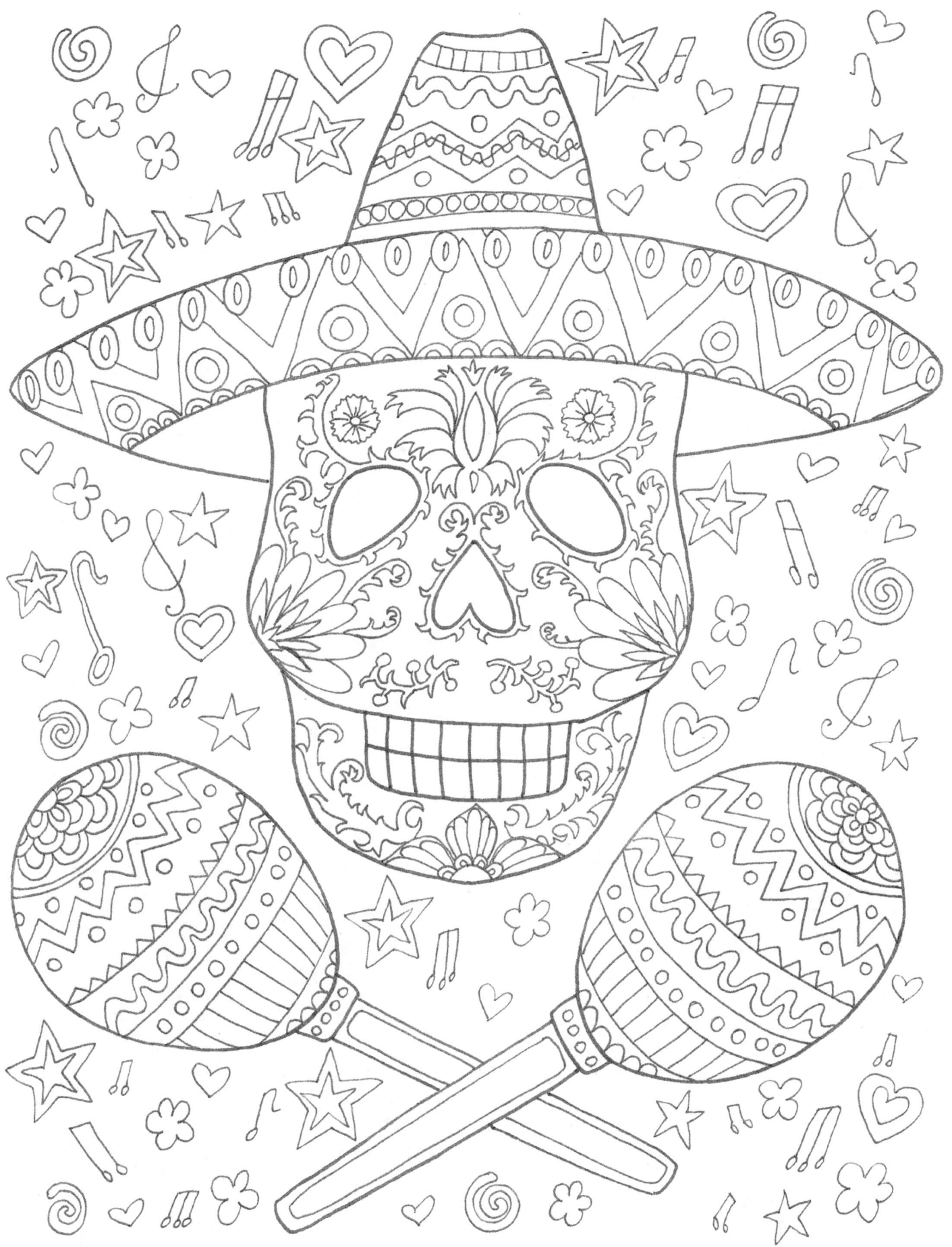

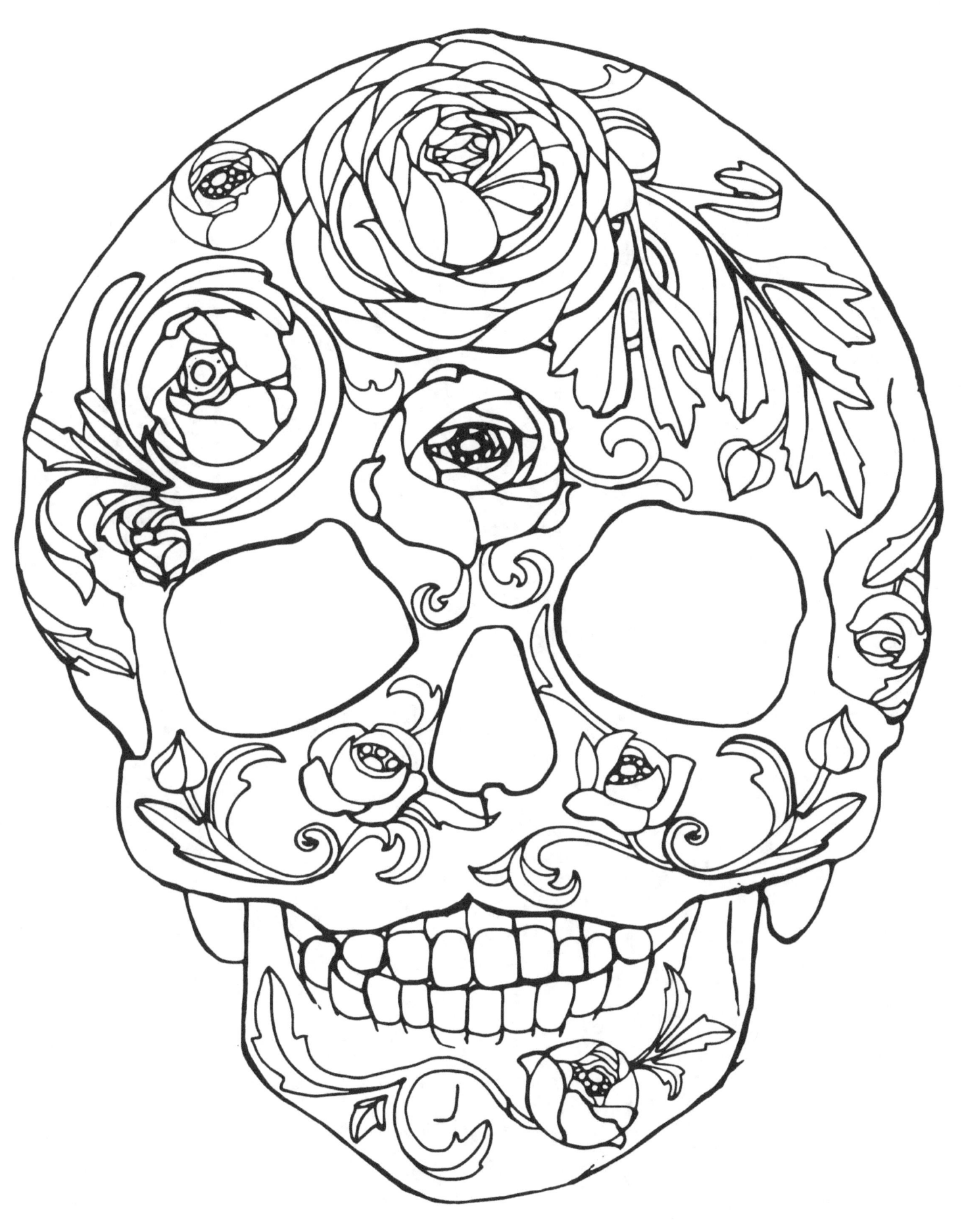

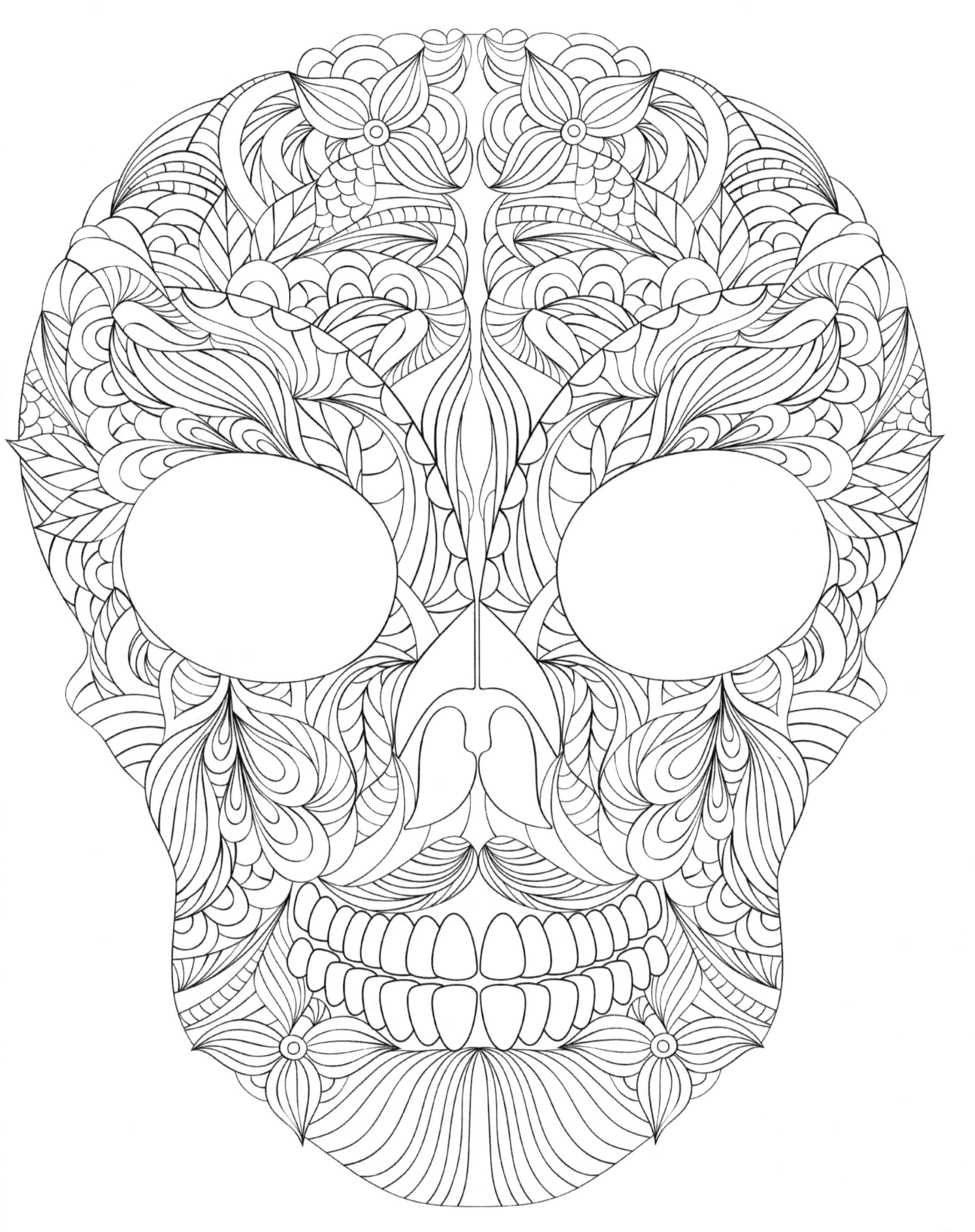

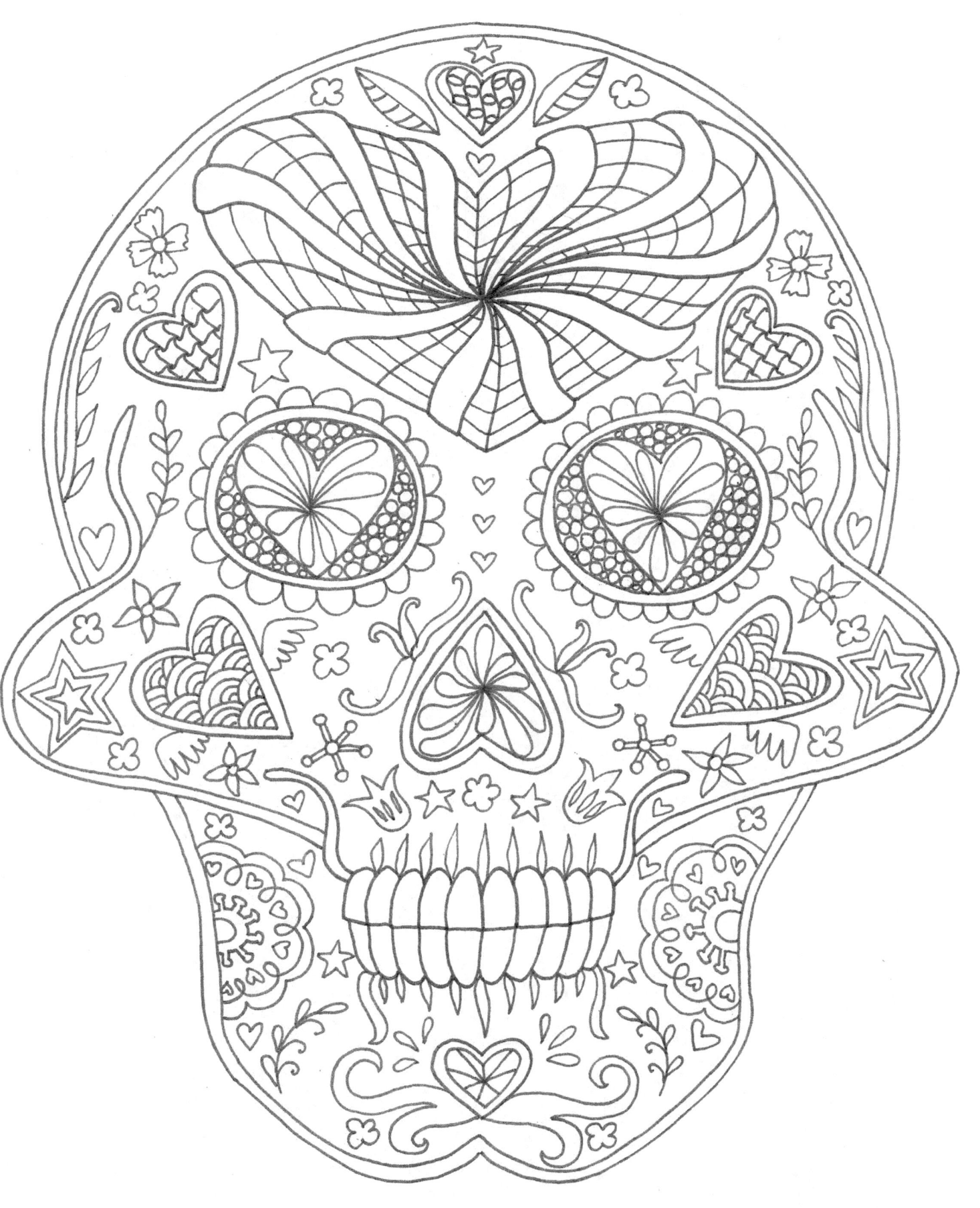

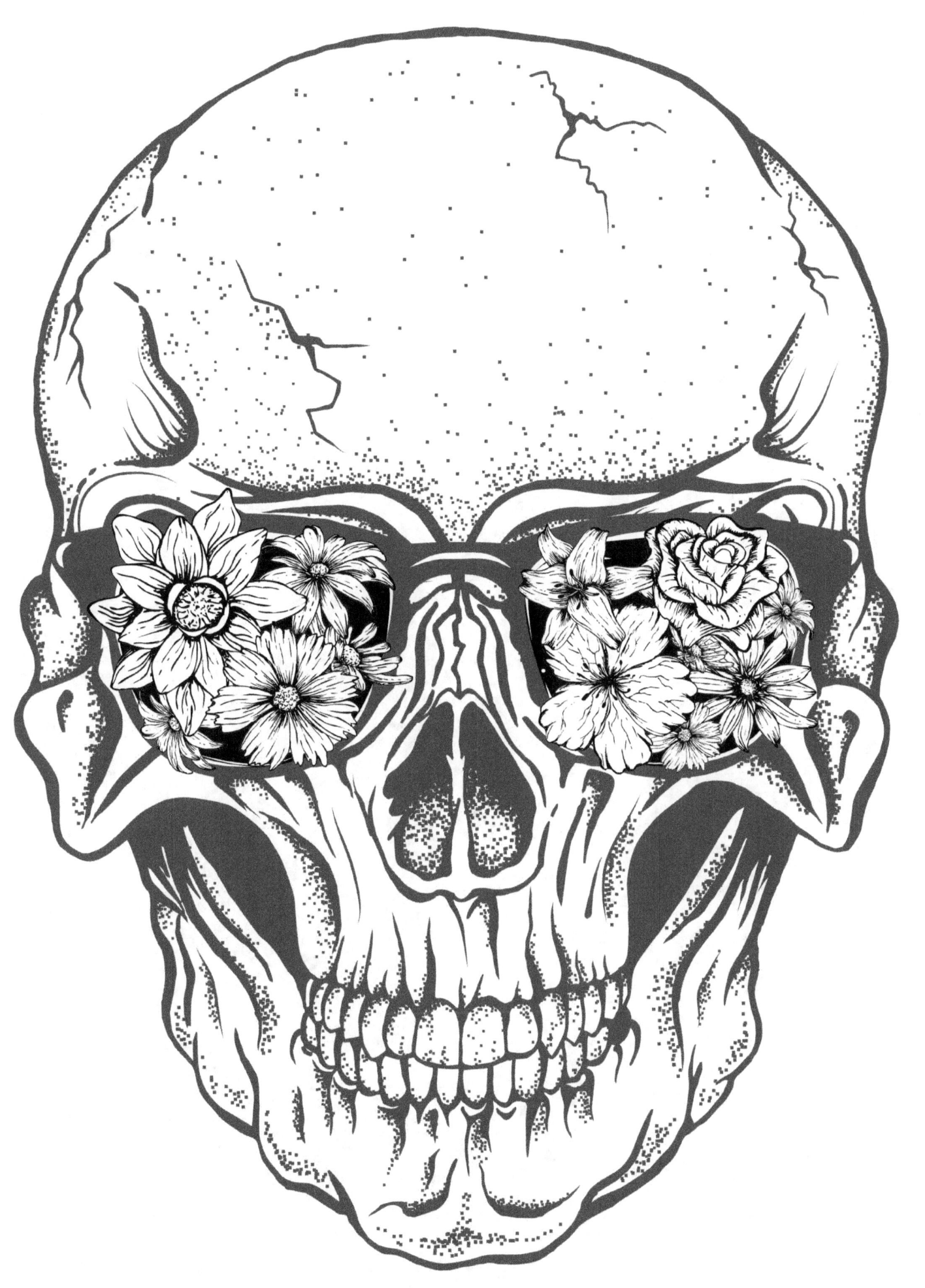

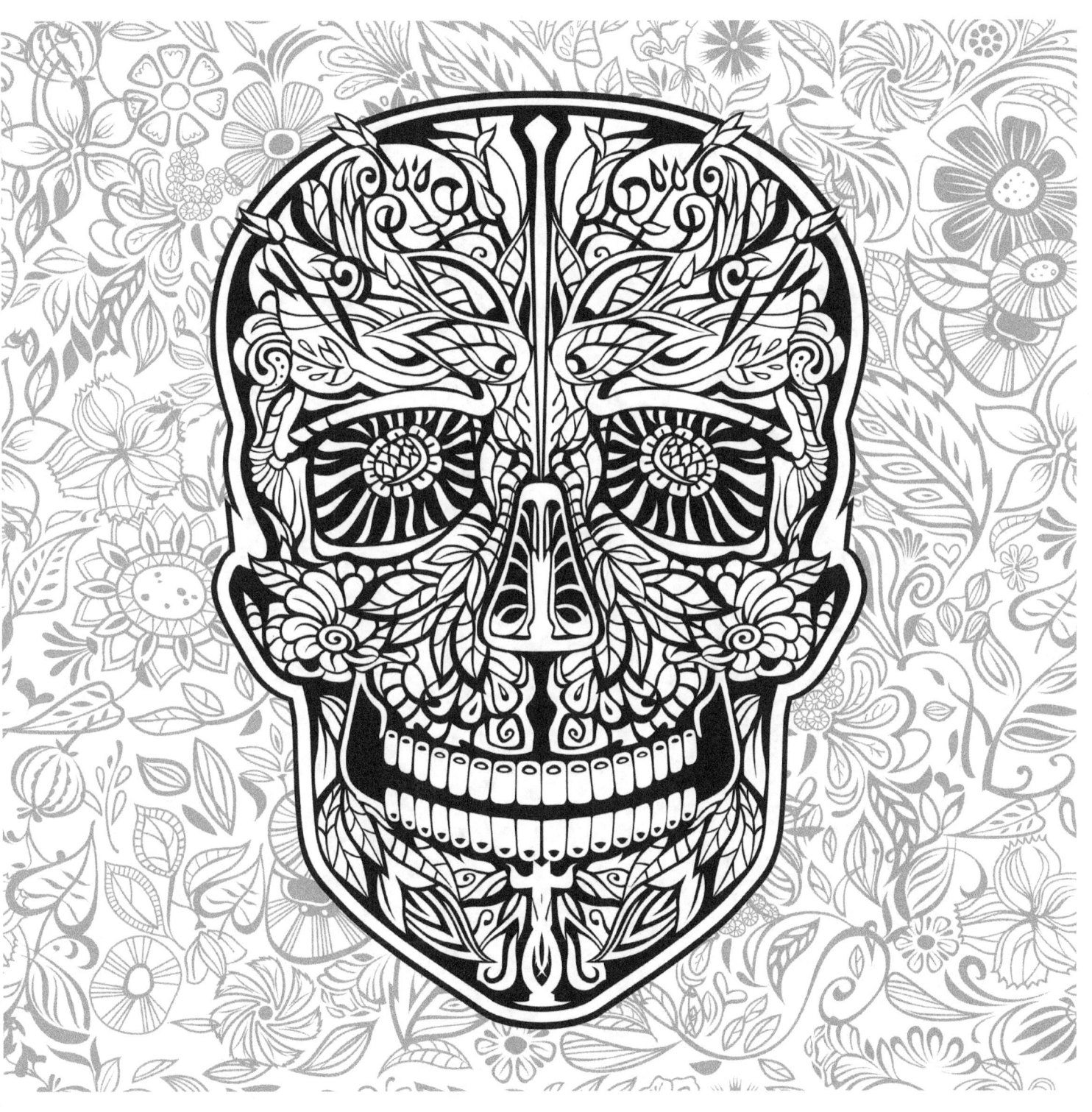

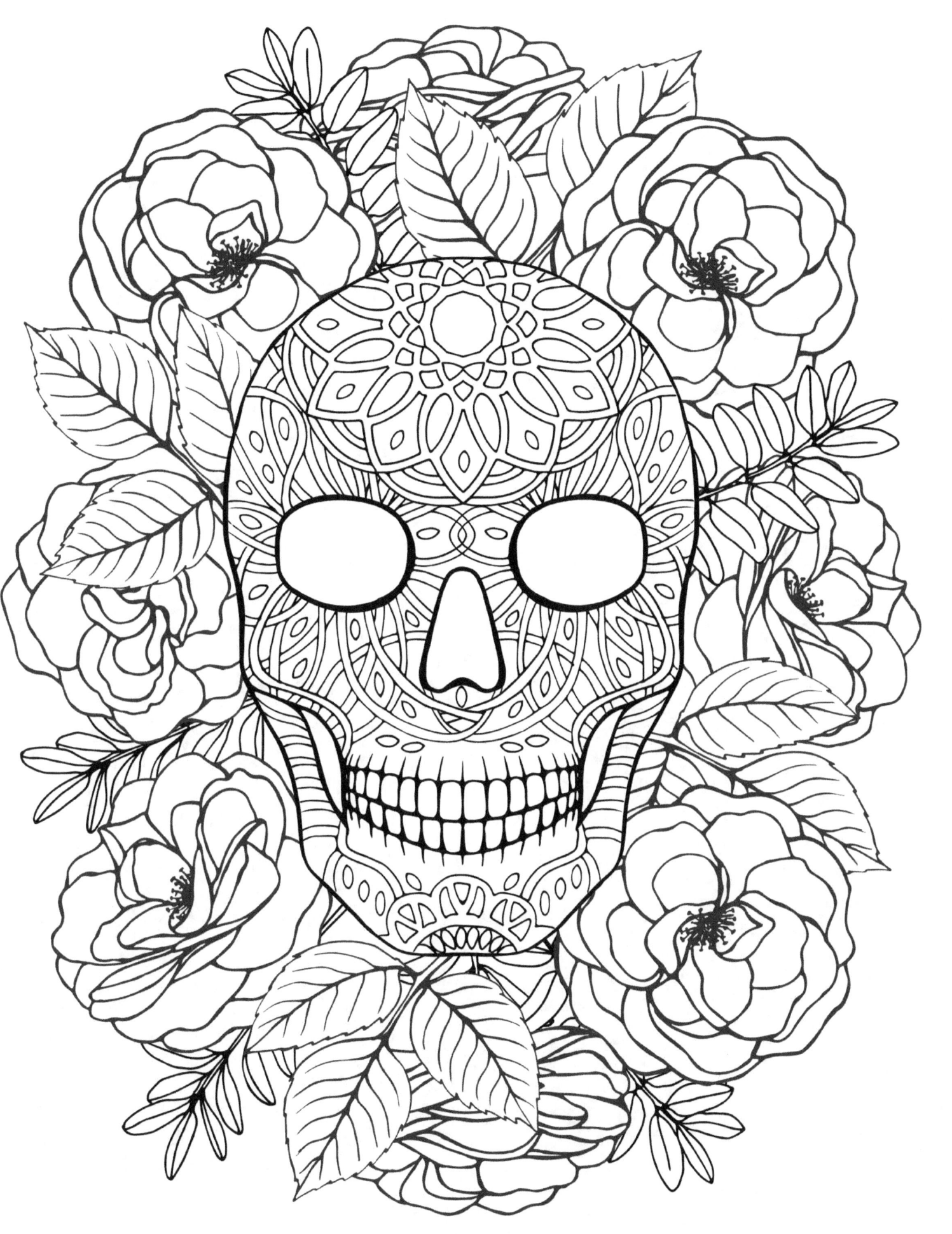

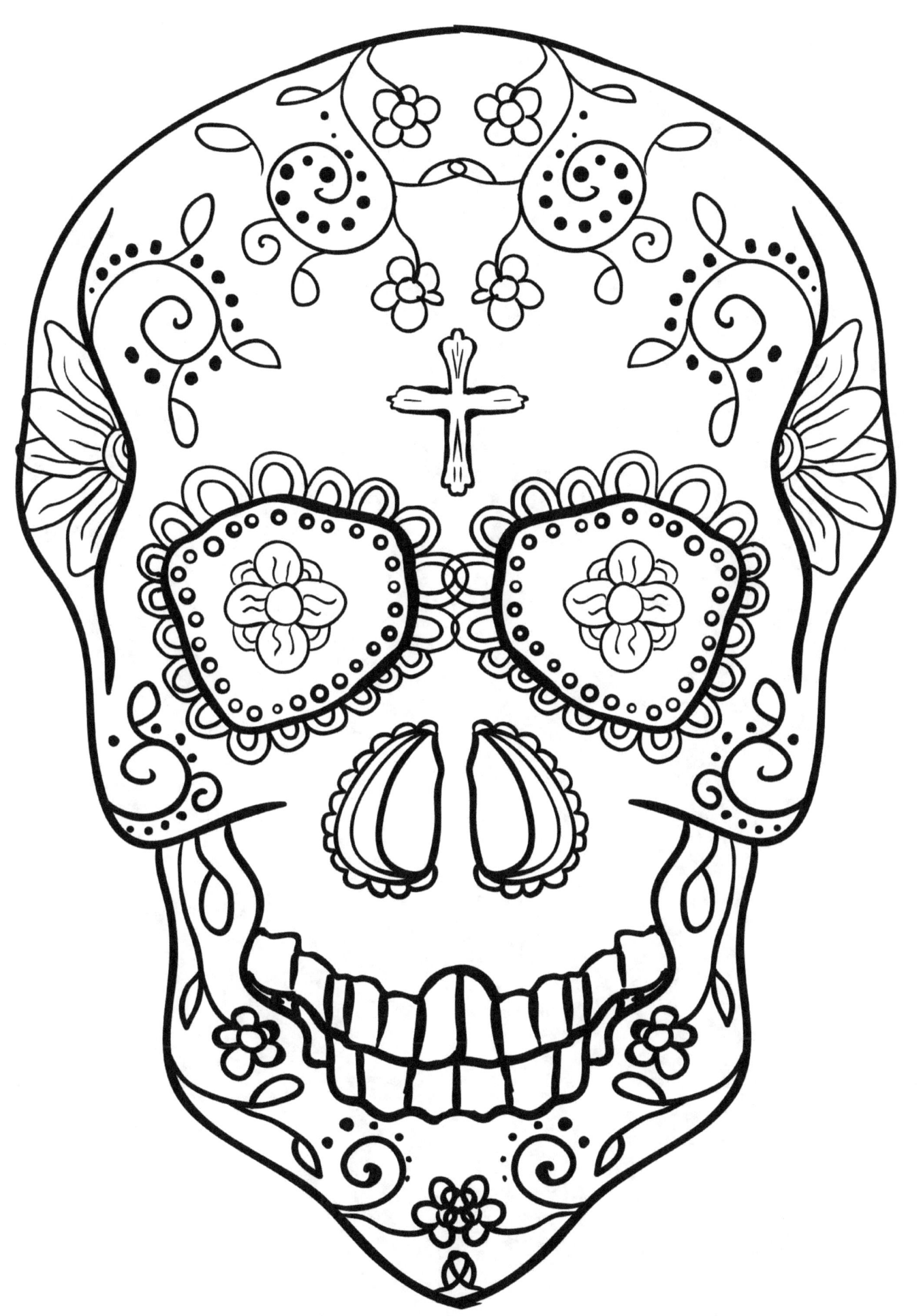

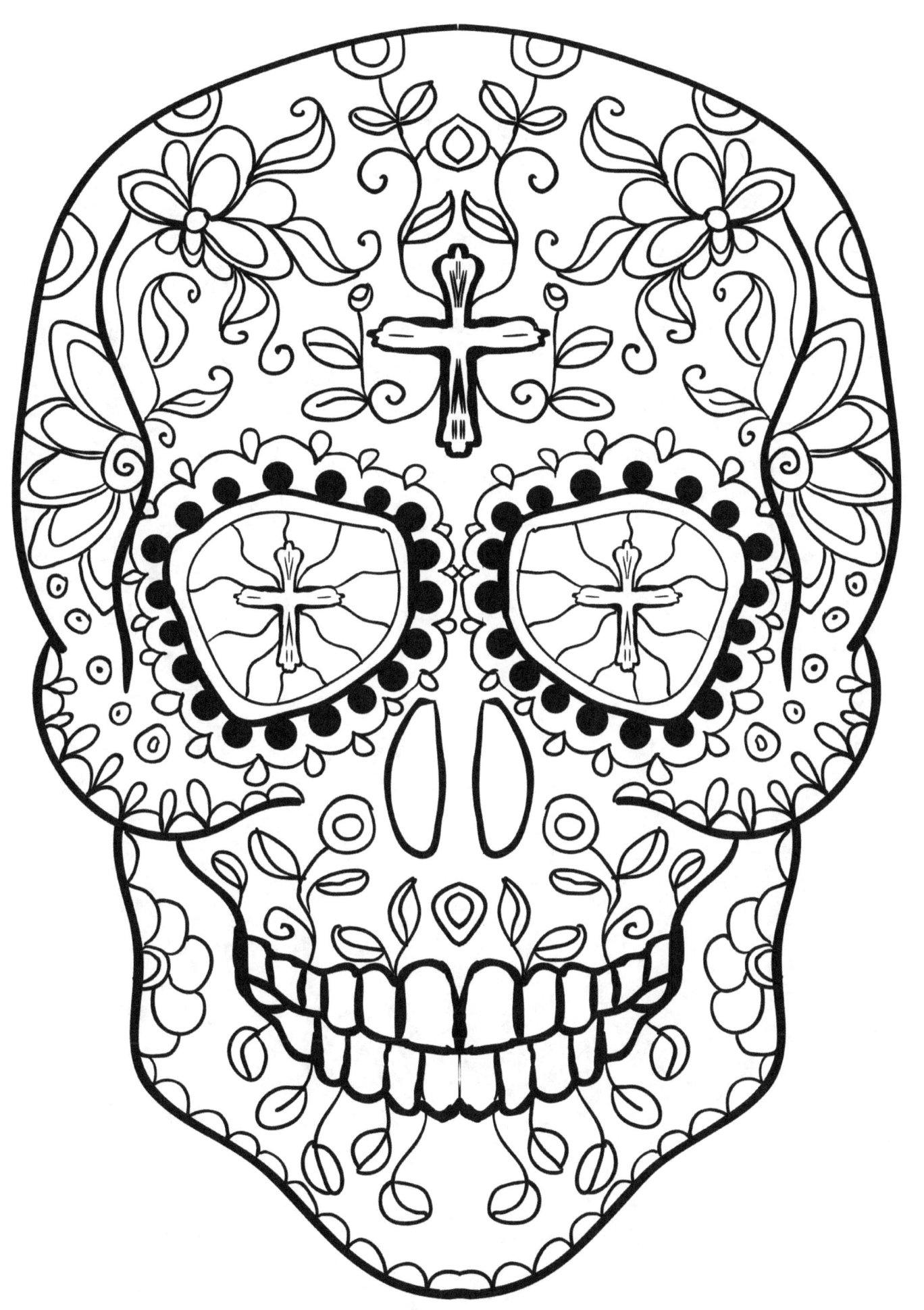

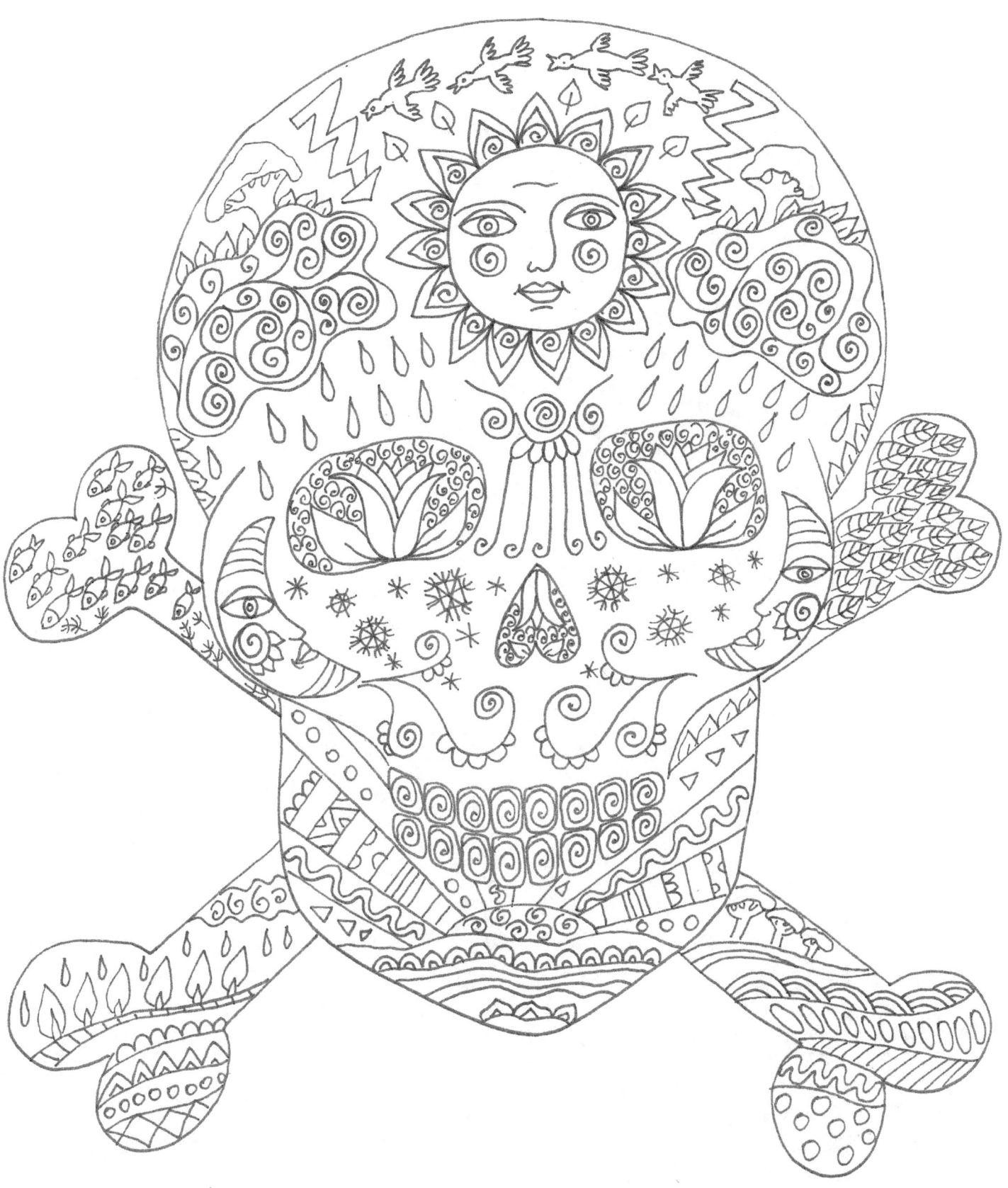

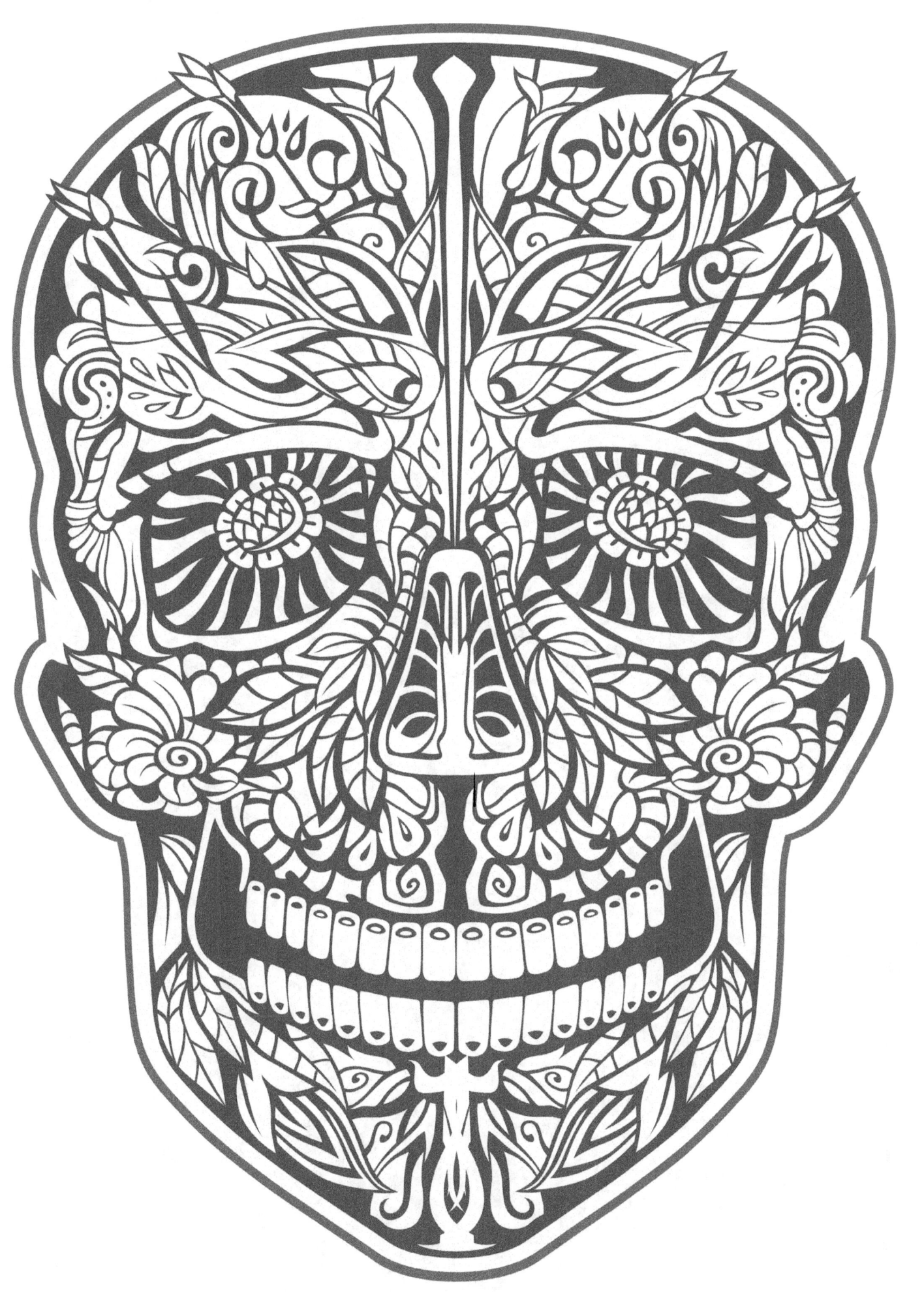

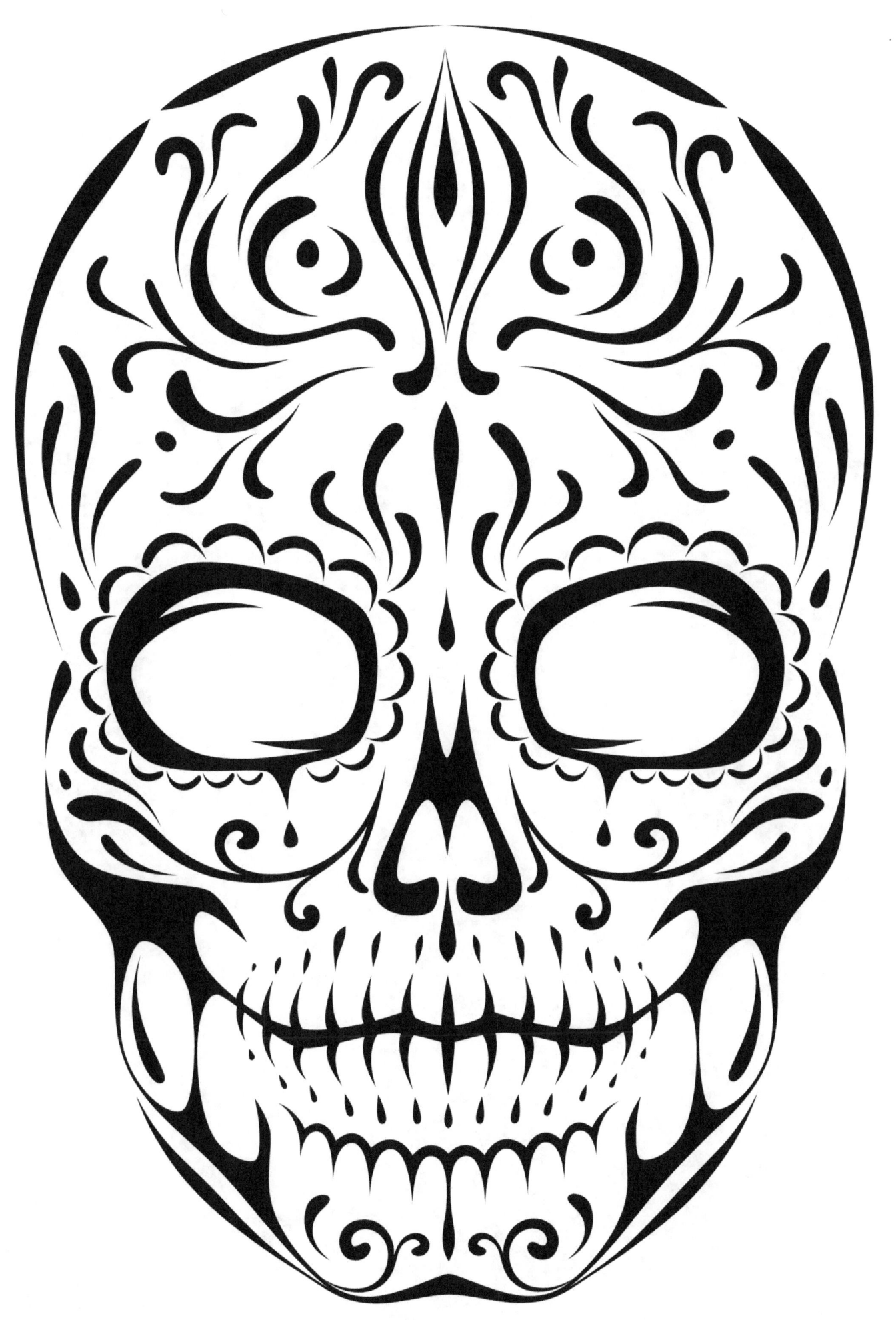

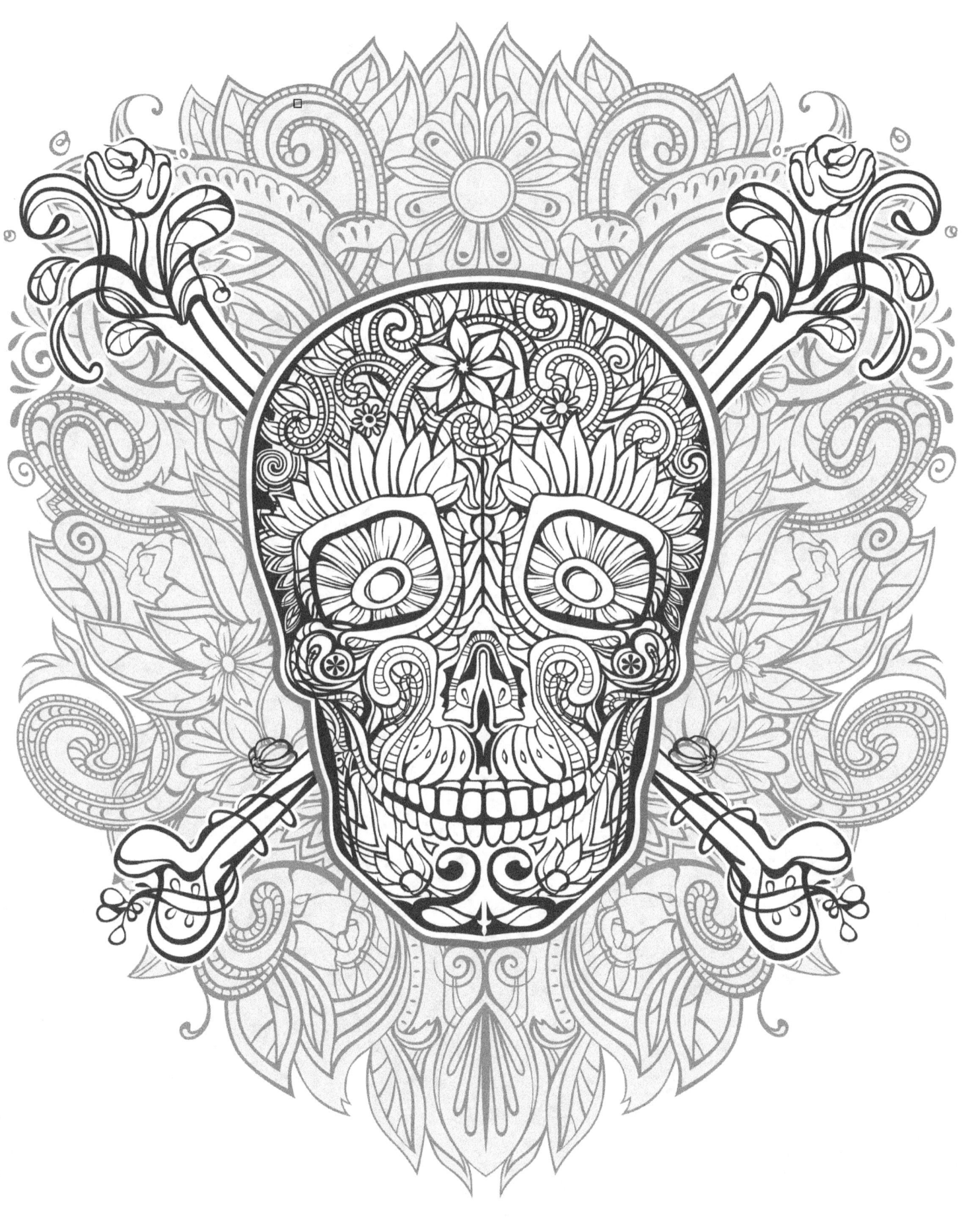

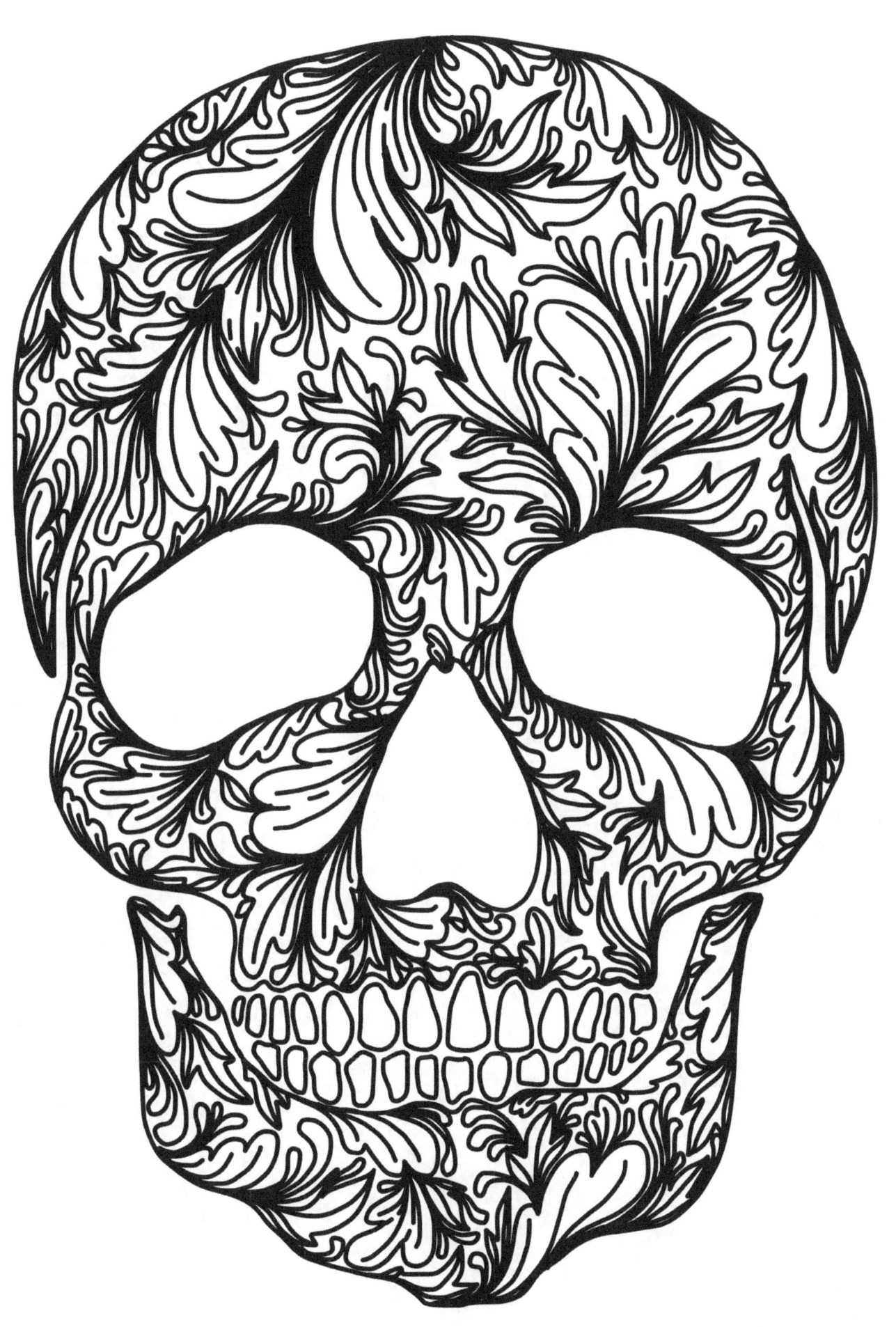